URBAN AVIARY

URBAN AVIARY

A MODERN GUIDE TO CITY BIRDS

STEPHEN MOSS
and Marc Martin

WHITE LION
PUBLISHING

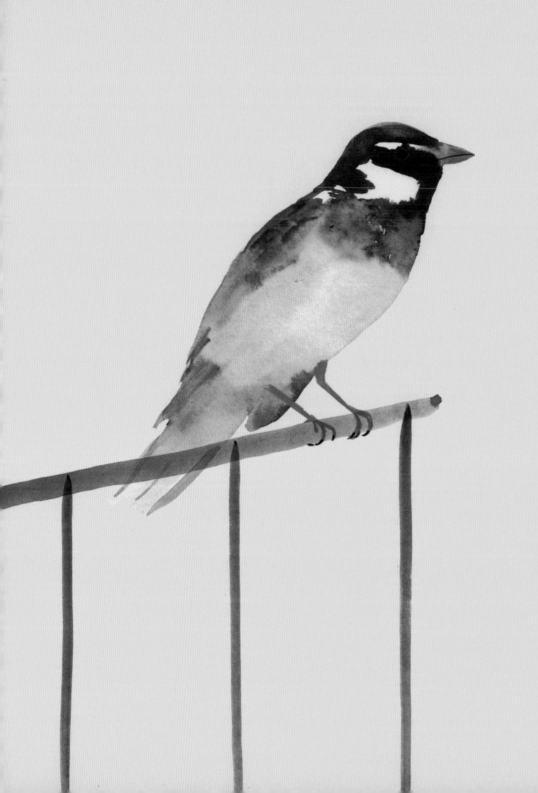

CONTENTS

INTRODUCTION

At first sight, the phrase 'Urban Jungle' suggests a bleak, lifeless, dystopian environment like the one portrayed in the film *Blade Runner*. Less dramatically, it is also perceived as a dull, grey, concrete city filled with drone-like commuters, travelling to and from their places of work.

Try looking at the phrase in a different way, however. If you take it literally, rather than metaphorically, then it begins to make sense. That's because many towns and cities around the world have become a haven for a wide range of wild creatures that have adapted to life alongside us in new, different and unexpected ways.

Think about this a little longer, and you will realise that a city can provide everything wildlife needs for survival. There is plenty of food – either accidentally or deliberately provided by us. There are sources of water and places to roost, shelter and breed. In temperate regions, cities tend to be several degrees warmer than their surroundings, particularly in winter. This effect has led to cities being described as 'urban heat islands', and allows the breeding season to get off to a head start.

No group of animals is more visible, ubiquitous or easier to see than birds. From the smallest hummingbirds to some of the largest birds on the planet, such as swans and ostriches, many birds have adapted to urban life. While this includes species we might expect – crows, gulls and pigeons, for example – there are also some real surprises.

Half a century or so ago, when the peregrine was threatened by poisoning and persecution, who would have imagined that the fastest creature on the planet would later become a regular resident in the centres of Barcelona, London and New York? Who expects to see hornbills in Kampala, turkey vultures in Washington, DC or the wrybill, one of the world's rarest waders, in Auckland?

From frigatebirds soaring over Rio de Janeiro to bowerbirds displaying in the suburbs of Canberra, from penguins in Cape Town to pelicans in San Francisco, and from flamingos in Montpellier to huge flocks of starlings roosting around the Colosseum in Rome, a remarkable array of avian sights, sounds and spectacles are to be

found in the world's cities. Birds have adapted to urban life, too – not least the crows of Tokyo, which use passing traffic to crush the shells of nuts so they can get at the food inside.

Today, more than half of the world's population makes its home in cities; by 2050, projections suggest that there will be close to ten billion people on our planet, and two-thirds will live in cities. In the industrialised West, the proportion is even higher: whereas in the year 1800 just one-fifth of Britons lived in towns and cities, today that has risen to over ninety per cent. The figures for China read just as dramatically, from just one in seven people in 1950 to close to half today. Even in the United States, often regarded as more rural in character than much of Europe, more than four out of five people are city dwellers.

This has crucial implications for the future of both birds and ourselves. If we welcome birds into our cities, by providing food, water and places to nest, we will benefit too. All the evidence shows that regular contact with nature improves our physical, mental and emotional health. If we shut out the birds, pushing them to the fringes and eventually providing nowhere for them to live, we will lose out as well. It's a simple choice.

For the past decade or so I have lived in Somerset, in the heart of the English countryside. But for the first half of my life I lived in and around London, where, as a child, I first discovered the wonders of birds.

Since then, I have travelled to all six of the world's inhabited continents, and enjoyed memorable days birding in cities from Lima to Reykjavík, Sydney to Seville, and Barcelona to Buenos Aires. That has given me a special love of urban birds, including many of the species I have chosen to include here.

This book aims to provide city dwellers around the world with a guide to some of the most extraordinary species of birds that live alongside them. By showing how these birds don't just survive, but thrive in our cities, I hope to encourage people to appreciate them, and welcome them into their busy lives.

STEPHEN MOSS

KEY

average length

average wingspan

average weight

Note on measurements

Measurements given in each entry's statistic box are the combined male and female average figure for a fully grown, adult bird. The length measurement for each entry is the distance from the tip of the beak to the tip of the tail. The wingspan measurement for each entry is the distance between the tips of the longest primary feathers on each wing when outstretched.

ANNA'S HUMMINGBIRD
Vancouver, Canada

10.5cm (4in)

12cm (4¾in)

4.5g (⅛oz)

The election resulted in a landslide, with the winner taking over forty per cent of the vote, easily beating her three rivals. This poll, held in the Canadian city of Vancouver in May 2017, wasn't won by a human candidate, but by a bird: Anna's hummingbird.

This tiny creature, weighing just 4.5g (⅛oz) on average, and only 10.5cm (4in) long, was named the city of Vancouver's official bird, in an online vote, beating the spotted towhee, varied thrush and northern flicker (a kind of woodpecker).

It certainly merits its win. Like all hummingbirds, this is a jewel-like creature, with iridescent feathers that sparkle and gleam as the bird turns towards the light, producing a flash of bright emerald. In spring and summer, the male develops a magenta head, face and throat, with a white flash through his eye.

It may come as a surprise that any hummingbird – a family usually associated with the tropics of South and Central America – would venture this far north at all. Yet Anna's is just one of several species that breed up the west coast of the United States and Canada, having spread north from California since the 1930s. And now, in a major change of habits, Anna's hummingbirds have begun to winter in the northern parts of their range – including Vancouver.

This is partly down to the urban heat-island effect (see page 6). But, here, it is also because Vancouver's citizens lend a helping hand to these tiny birds, putting out sugar water on which they feed, and making sure that this doesn't freeze during cold spells. The planting of nectar-rich flowers – some of which bloom in winter – has also helped the hummingbirds survive.

The birds pay back their human neighbours by hovering in full view to feed, and through their entertainingly aggressive antics: the male chases off any rival that dares to enter its territory. At night, these incredibly active little birds slow their metabolism right down, becoming torpid in order to conserve their energy until the next day, when they can feed once again.

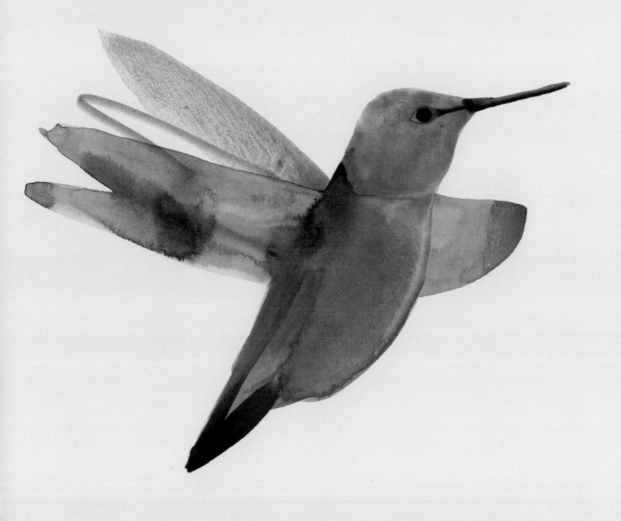

NORTHERN HOUSE WREN

Edmonton, Canada

12cm (4¾in)

15cm (6in)

12g (½oz)

Like other birds named after our dwelling places – the house sparrow and house martin, for example – the house wren is well adapted to life alongside people in towns and cities throughout North, Central and South America.

Because they are so common, widespread and relatively easy to see, house wrens have been part of one of the longest-running studies into the effects of urbanisation on birds. This has involved professional scientists – who give the birds coloured rings on their legs so that they can easily be identified – and members of the public, who have carried out invaluable observations over many years.

One key finding of this study was that birds in urban areas are less likely to have their nests robbed by predators. On the downside, city birds suffer more from diseases, presumably because they live cheek-by-jowl alongside one another – much like us!

The Canadian city of Edmonton, capital of the province of Alberta, is towards the northern limit of the wren's range – partly because it has a warmer climate than other locations on the same latitude. House wrens also like fairly scrubby habitats, which is provided by the farmland and prairies that surround the city. The birds arrive back from their winter quarters in late April, and are regarded – along with the swallows – as a key sign of spring. They are also liked because of their habit of nesting in peculiar places, including vases, empty dog-food containers and the skulls of cows.

House wrens have a darker side. Despite their small size, they are able to evict much larger species, including Baltimore orioles and American robins, from their nests, by sheer force of personality. They even remove the eggs and chicks of these birds in the process. For a time, this made them quite an unpopular species, even amongst professional ornithologists.

The house wren is often cited as one of the most widespread birds in the Americas, being found as far south as Tierra del Fuego, in Argentina. In the last decade, DNA studies have revealed that there are actually two species – the northern and southern house wren – rather than one. Both species, however, live up to their names, and spend much of their lives alongside us.

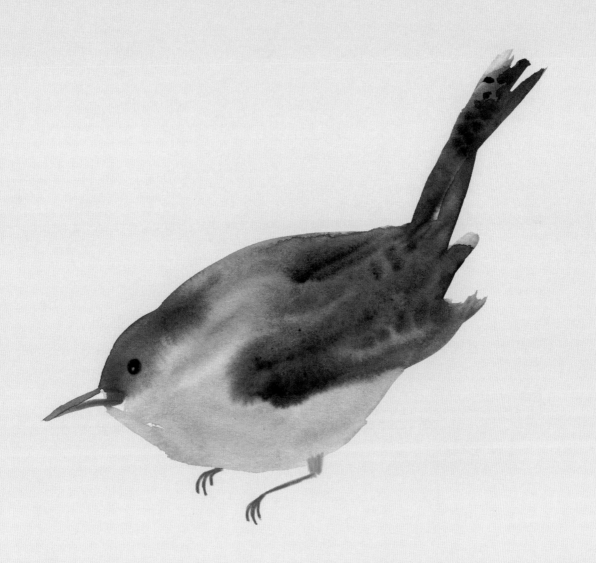

BROWN PELICAN
San Francisco, USA

1.2m (4ft)

2m (6½ft)

3.5kg (7¾lb)

Drivers crossing San Francisco's landmark Golden Gate Bridge may be momentarily distracted by seeing one of the world's largest waterbirds plunging into the sea below. The brown pelican is the only one of the world's eight pelican species to hunt from the air, and often doing so in flocks – this species is very sociable and gregarious.

Having caught fish with its huge bill, a pelican then stores its catch in the pouch hanging below. After returning to land, it can then consume the catch. Once they have eaten their fill, groups of pelicans often roost on breakwaters on nearby shorelines and islands, including the aptly named Bird Island, as well as Alcatraz – once considered the world's most secure prison, and home to the famous 'Birdman'. The name 'Alcatraz' actually derives from an Old Spanish (originally Arabic) word meaning 'pelican'.

As its name suggests, this is the only predominantly brown pelican species (the rest are mainly white). Young birds are almost entirely brown, but adults have white necks, yellow heads and – throughout the breeding season – red bills.

During the nineteenth century, pelicans were so numerous on the island that they made a sound said to be as loud as a hurricane. In the early twentieth century, pelicans – along with other waterbirds such as grebes and egrets – were slaughtered to supply the fashion industry with plumes.

More recently, the brown pelican has also been vulnerable to fish shortages, and also to pollution events such as oil spills. Since the turn of the twenty-first century, however, numbers have risen, thanks partly to the banning of agricultural chemicals such as DDT, and the species is no longer classified as endangered. Today, there are around 10,000 pairs in California as a whole.

Brown pelicans head south in January to breed in southern California and Mexico, and then return to San Francisco in July or August, where, once again, large flocks can be seen flying high over the city skyline before plunging down into the bay. In the last ten years, a shortage of sardines in the warmer regions – caused by overfishing – has led to reduced breeding success, so that the pelicans may now return as early as May.

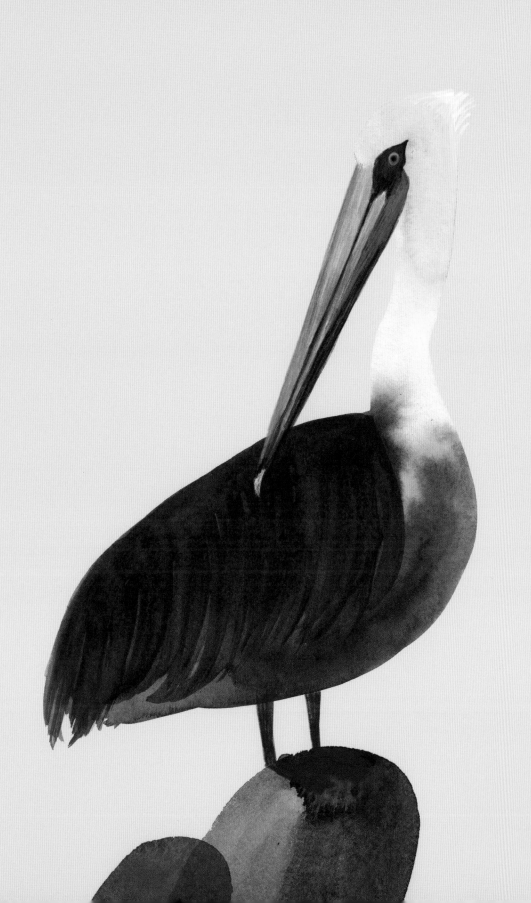

BALD EAGLE
Denver, USA

Some birds are simply more charismatic than others, and so seem to capture the public imagination. One such bird is the bald eagle, America's national bird. This accolade was given in 1782, though, at the time, the great US statesman Benjamin Franklin disagreed. He considered this scavenger most unsuitable, preferring the wild turkey.

With a wingspan of 2.1m (7ft) on average, the bald eagle is one of North America's largest birds of prey, beaten in size only by the very rare California condor. An adult bald eagle is unmistakable, with a dark-brown body and wings, a powerful yellow bill and the snow-white head that gives the species its name.

In Denver, the capital city of the state of Colorado, local residents avidly watch a webcam showing a pair of breeding bald eagles that has chosen to nest on the Fort St. Vrain Generating Station to the north of the city. The birds often feature on local and regional news, and also on social media. The bald eagle appears on the Seal of Denver City and County, as well as on many other federal and state documents.

The webcam was first installed on the power station in 2003, though the nest was established long before then. Each year the eagles add more twigs to the nest; the structure is now almost 8m (26ft) in diameter and can even be seen on satellite photos taken from space. So far, successive pairs of eagles have raised thirty-three chicks there.

Recently, a bald eagle even took up residence in the heart of the city, Denver's City Park, where it hunted, caught and ate fish, ducks and geese.

The success of bald eagles – not just in Denver but in cities throughout North America – is astonishing given that, just a few decades ago, the species almost went extinct in the United States, thanks to persecution and poisoning by agricultural pesticides. Today, now that these problems have largely been solved, the US population is estimated to be a very healthy 5,000 pairs, with 70,000 pairs in North America as a whole.

83cm (32¾in)

2.1m (7ft)

4.7kg (10¼lb)

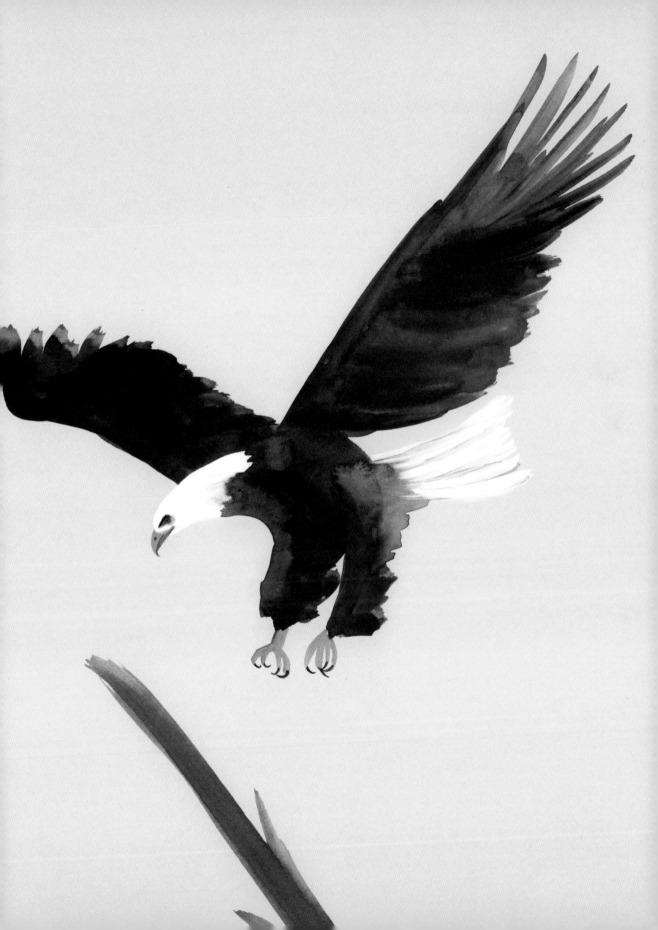

GOLDEN-CHEEKED WARBLER

San Antonio, USA

13cm (5in)

20cm (8in)

11g (⅓oz)

Unlike the Old World warblers of Europe, Asia and Africa – usually drab and hard to identify – the entirely unrelated New World warblers are often beautifully coloured. Few are as handsome as the golden-cheeked warbler, the only species of bird that breeds solely in the state of Texas and nowhere else on the planet.

With its mostly black plumage, white wing bars and belly, and bright-yellow cheeks, this little bird is also incredibly rare, with an estimated population of fewer than 1,000 singing males.

Even in Texas, the golden-cheeked warbler has a very limited range, essentially a narrow strip running diagonally from northeast to southwest through the centre of the state. This passes right through the city of San Antonio, where the warbler's distinctive buzzing song can be heard from oak trees and junipers, where it makes its nest out of fragments of tree bark held together by spiderwebs.

The city stronghold for these endangered birds is the 250-hectare (618-acre) Friedrich Wilderness Park, next to a large housing estate on the north side of San Antonio. This provides exactly the right habitat for the warblers, and also allows city dwellers to follow trails to see them. Unfortunately, most of their special juniper-oak habitat has been cleared; a destructive process that was noted as early as 1892 by the pioneering Texas naturalist Henry P. Attwater.

Golden-cheeked warblers are only present in San Antonio and the rest of their central Texas range for four months of the year, between March and June. After breeding, they head south to spend the winter in the wilds of Mexico's Sierra Madre mountains, and further south, in parts of Central America. The following spring, the males arrive back a few days before their mates, to establish their territories. Even when the females do return, they are rarely seen, as they hide amongst the dense foliage.

As with many rare and specialised songbirds, the golden-cheeked warbler is threatened by a range of factors, including habitat loss through urban development. The presence of deer and goats, which reduce the amount of vegetation through grazing and browsing, may also be a factor in the warbler's decline.

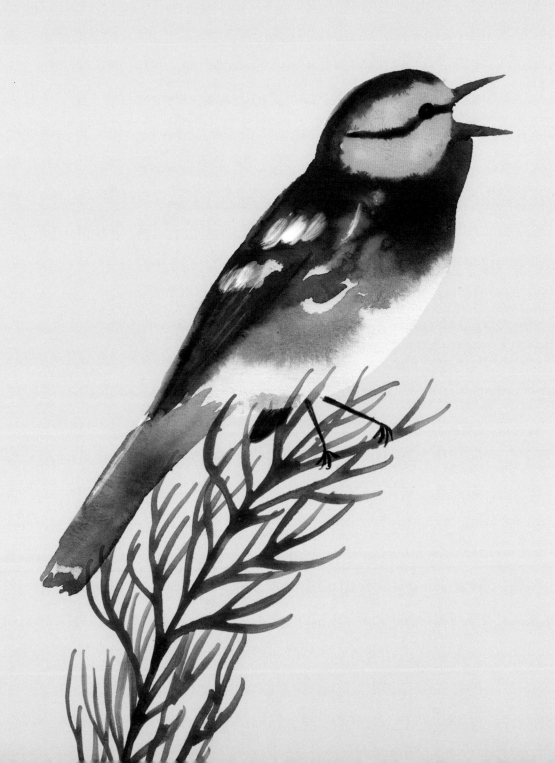

PURPLE MARTIN
Houston, USA

Swallows and martins are well known for their close association with human beings, and their habit of nesting in and around our homes and outbuildings. Two familiar species – the barn swallow and house martin – are even named after this association.

19.5cm (7¾in)

40cm (15¾in)

55g (2oz)

But of all the eighty-plus members of this family, none are quite so closely associated with town and city life as the purple martin of North America. This handsome bird not only uses man-made structures in which to nest, but has encouraged more than one million people in Canada and the United States to put up specially designed communal bird boxes, where the birds can breed safely.

The natural nest site of the purple martin is the cavity of a tree or, in the southwestern United States, in the huge saguaro cactus. Throughout the eastern half of the country, however, they choose to nest alongside people – indeed they are now almost entirely dependent on artificial nest sites.

The Texas city of Houston – famous for oil and NASA's mission control – is one of the first places where purple martins are seen each year, with males returning from their winter quarters in South America as early as January. They soon settle down to breed here, yet despite this early start they only raise one brood, of between three and six young.

Providing bird boxes for the martins is a longstanding tradition: it is thought that this may have been begun because purple martins mainly feed on flying insects – including fire ants, which bite humans – but people soon began to enjoy the birds' company for its own sake.

Despite the help they get from humans, purple martins are suffering major population crashes, due to a lack of flying insects caused by air pollution. But in July and August, after they have finished breeding, large numbers of purple martins gather each evening to roost in and around Houston.

Traditional roosts are often found in shopping malls, where the lights may deter predators; on some evenings the skies above the malls can appear black with thousands of birds. They are even seen on weather radar, especially when they disperse to feed in the early mornings.

COMMON NIGHTHAWK

Chicago, USA

Some birds retain an air of mystery and, of all the world's species, the nightjar family is more mysterious than most. Its eighty-plus members are mainly nocturnal, hunting by night for flying insects. They grab their prey using wide bills, which have special trigger hairs around the gape to detect contact with insects in the dark.

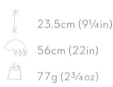

23.5cm (9¼in)

56cm (22in)

77g (2¾oz)

There are seven nightjar species in North America, of which by far the most widespread is the common nighthawk. This species is found throughout most of the lower forty-eight states, and its range also extends northwards into Canada.

Widespread it may be, but this species has suffered a major population decline during the past few decades, declining by up to ninety-five per cent in some areas. Fortunately, it continues to thrive in some major cities, including Chicago – though nighthawks have virtually disappeared from New York.

On the southern shore of Lake Michigan – one of the five Great Lakes along the border between the United States and Canada, Chicago is also known as the Windy City, because of a constant wind that blows in from the lake's surface. Nighthawks gather here in large numbers in August, prior to migrating south before winter. They spend the winter months in southern South America, making theirs one of the longest migrations of any American land bird.

Nighthawks are attracted to cities by the concentrations of flying insects under street lights, which the birds mainly hunt around dawn and dusk. They have a bat-like appearance in flight, leading to the folk name 'bullbats'. As they hunt, they often utter piercing calls, a familiar part of the urban soundscape that is audible even above traffic.

Chicago's nighthawks often nest on rooftops, an analogue to their habitat in the wild, where they nest on raised ground in prairies or grassland. This behaviour was first reported as early as 1869, and presumably evolved so that the birds could avoid land-based predators.

Elsewhere in the United States, urban nighthawks are celebrated in the name of the American Football team Omaha Nighthawks, based in Nebraska's largest city. Nebraska was once known as the 'bugeater state' – from an old name for the species.

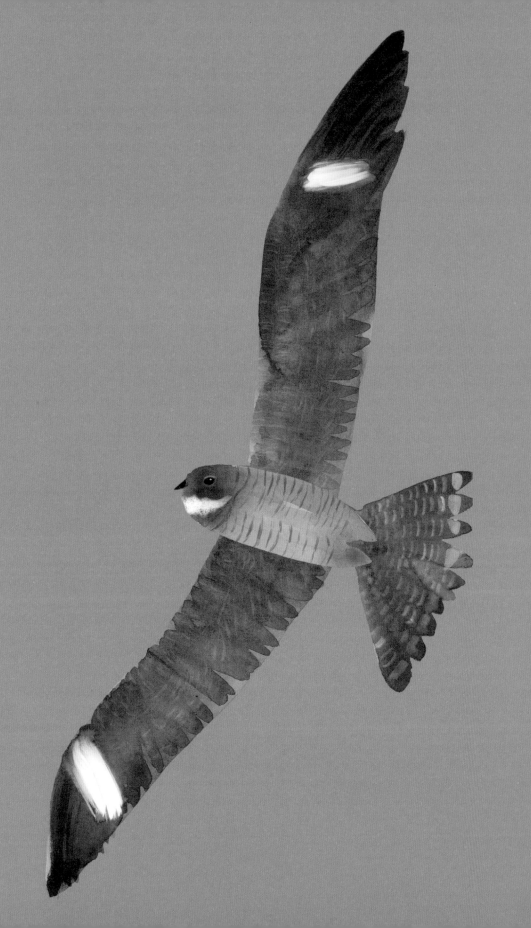

NORTHERN MOCKINGBIRD

Miami, USA

25.5cm (10in)

33cm (13in)

46g (1½oz)

The southeastern state of Florida is one of the most bird-rich places in the United States, with many species having adapted well to living alongside human beings. But in the state's second-largest city, Miami, one familiar bird is causing problems.

Northern mockingbirds – the only members of this tropical family found in the United States – are dive-bombing passers-by as they walk through the city's leafy suburbs and parks. The birds have even taken to attacking golfers as they try to focus on their tee shots or putts. The usual method of attack is to swoop down behind an unsuspecting target and peck him or her on the back of the head.

The reason for this aggression is that, when breeding, mockingbirds have plenty of enemies, from rapacious hawks to domestic cats, and need to defend themselves. People simply look like giant predators, and so get the same treatment, even when they mean the birds no harm. Some biologists claim that the birds are learning to recognise individual intruders, who they attack even more fiercely.

Generally, though, the people of Miami are fond of mockingbirds. As the name suggests, these birds are accomplished mimics, able to master up to 200 different songs and other sounds, including alarm clocks, car horns and other animals, such as frogs and squirrels. As with other great avian songsters, this ability arises from runaway sexual selection, in which a female chooses a male with the most varied and impressive songs. This in turn leads to male mockingbirds striving even harder to outdo their rivals. One downside is that unmated male mockingbirds will sing persistently through the night – keeping the citizens of Miami awake into the small hours.

The northern mockingbird – famous, of course, for Harper Lee's Pulitzer prize-winning novel and Oscar-winning film – is Florida's national bird. It has been so since 1927. Given that it shares this honour with four other states – Texas, Arkansas, Mississippi and Tennessee – there are suggestions that it should be replaced. Maybe something a bit more colourful and exotic would better reflect the nature of life in downtown Miami, one suggestion being the strawberry-yogurt-coloured roseate spoonbill.

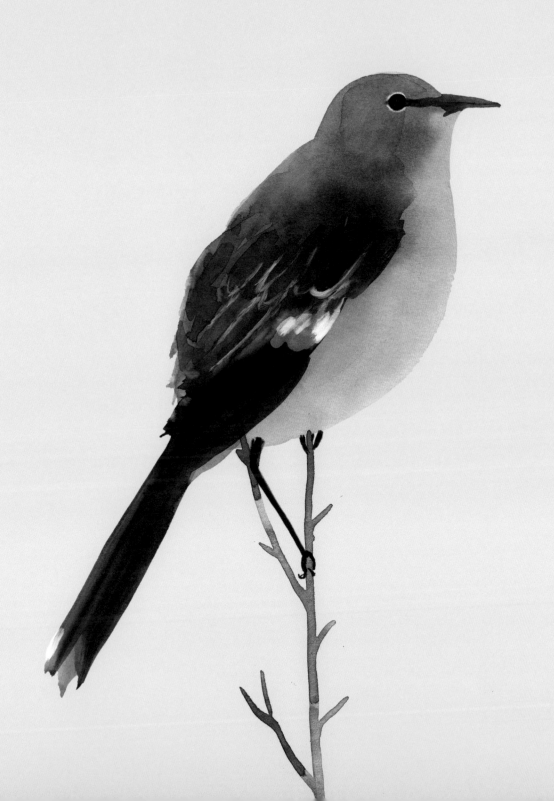

TURKEY VULTURE
Washington DC, USA

71.5cm (28in)

1.7m (5½ft)

1.4kg (3lb)

No cowboy movie is complete without the immortal line 'the buzzards are circlin' overhead', but those broad-winged birds soaring high in the sky are not buzzards (a Eurasian species), they are turkey vultures. Once confined to the Wild West and other remote parts of the Americas, turkey vultures are now a regular sight over the United States's capital city, Washington, DC. The bird rarely breeds inside the city boundaries, however, preferring to nest in caves and rocky crevices outside.

Like other urban raptors – such as black kites in Asia, yellow-billed kites in Africa and black vultures across the southern United States, and Central and South America – turkey vultures are attracted to cities because of the plentiful quantities of waste food available there. These birds are scavengers: they are one of very few species with a highly developed sense of smell that enables them to locate food from some distance away. They are also very sociable, gathering in flocks of up to several hundred birds.

Vultures are both an asset and a problem for city dwellers. They do a great job in clearing up roadkill and waste food, helping to prevent diseases such as botulism from spreading. Yet the birds cause local damage at their roosts, where their faeces whitewash trees and fall on vehicles below.

They are also helped by the urban heat-island effect: warmer cities have allowed this species – and its cousin the black vulture – to spread further north than ever before. Turkey vultures are certainly on the increase in Washington, leading to more and more complaints about their behaviour. They have even been accused of hanging around in gangs and terrorising local neighbourhoods.

Ecologists are fascinated by the vultures' success: after all, if we could understand why they have managed to adapt so well to living in our crowded cities, we might perhaps be able to learn lessons on how to save other, more endangered species.

However, scientists studying these fascinating birds have learned not to get too close. When cornered, a turkey vulture will vomit its highly acidic stomach contents, which can easily burn human skin.

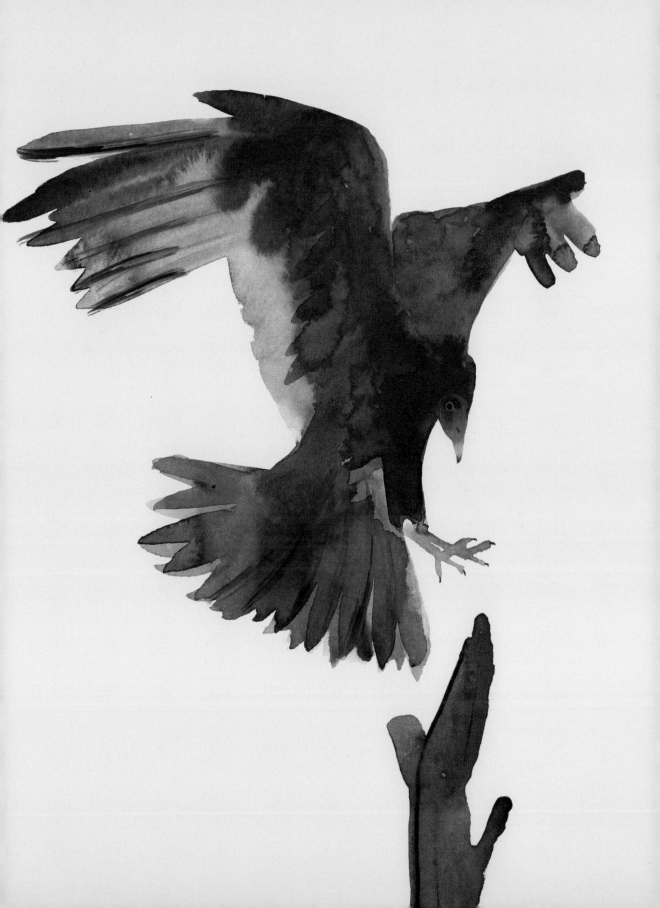

RED-TAILED HAWK
New York, USA

City skyscrapers are not just homes or workplaces for people; birds of prey often adopt them, also, as 'analogue habitats' – the man-made equivalent to a natural cliff or crag. When a pair of birds nests on a tall building it often attracts attention, but few birds can rival the celebrity of a dynasty of red-tailed hawks that set up home on New York's famous Fifth Avenue in the 1990s.

51.5cm (20¼in)

1.2m (4ft)

1.1kg (2½lb)

Until the late-twentieth century, most species of North American raptor were in decline, following decades of poisoning and persecution. When a male red-tailed hawk – a medium-sized raptor with a 1.2m (4ft) wingspan – turned up in the Big Apple in the early 1990s, he was soon given a name: the rather unimaginative 'Pale Male' (after his unusually light coloration).

In his first year, 1991, Pale Male built a nest in a natural site – a tall tree – but was soon seen off by the local crows. The next year, he chose the top of a building, where the nest has been ever since. This is an exclusive neighbourhood: the birds regularly perch on the balcony belonging to movie director Woody Allen.

Soon, people began writing articles and books about the hawks, and a documentary was made about them. Adopted as a symbol of wild nature by New Yorkers, they have come to represent a ray of hope in an increasingly troubled world.

In December 2004, there was a media frenzy when the hawks' nest was removed. Following an outcry, an artificial platform was erected, but metal spikes in the structure prevented the female from rolling her eggs, so no chicks hatched for the next six years.

Fortunately, there are now at least thirty other red-tailed hawk nests in New York, where the birds are easily seen as they float above the skyline searching for food – mostly pigeons and rats. The downside to this is that some hawks have died after ingesting rats whose bodies contained poison.

Pale Male outlived several of his mates, but is now believed to have died. Today, a new male nests in the same place. He, too, is light in shade, so is thought to be one of Pale Male's many offspring.

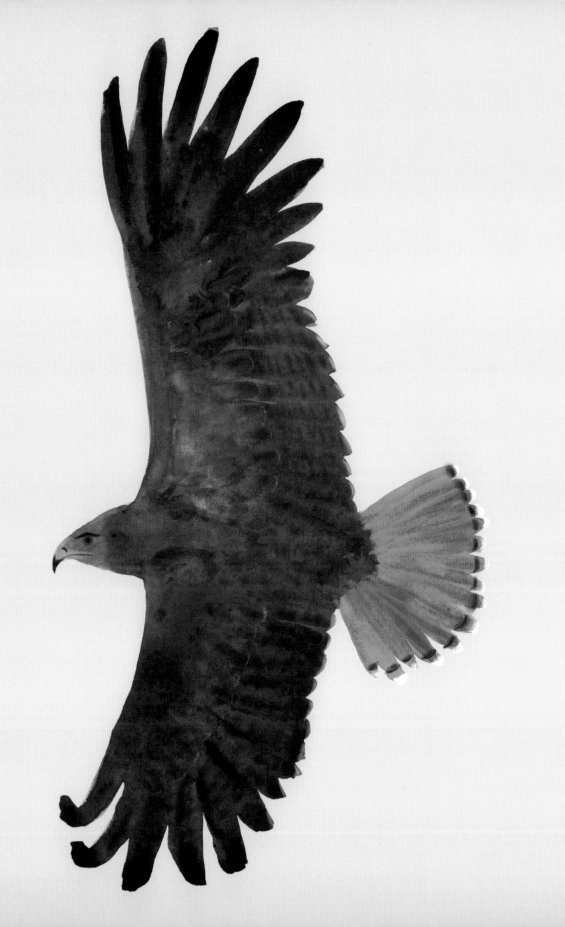

HOUSE FINCH

Honolulu, USA

14cm (5½in)

22.5cm (8¾in)

23g (¾oz)

The house finch has long been a popular cage bird in the United States and Mexico, kept as a pet because of its attractive rose-red plumage and pleasant, tuneful song. Originally found only in the western half of North America, from the nineteenth century onwards they were shipped in their thousands to the east coast, especially the cities of Boston and New York, where they were sold as 'Hollywood finches'.

Inevitably, many of these birds escaped. Others were deliberately let go, especially once the 1918 Migratory Bird Treaty Act made it illegal to transport the birds. Even then, the trade in house finches continued. By the late 1930s, a police crackdown led to thousands of the birds being released. Today, the house finch is one of the commonest and most widespread of all of North America's birds, found everywhere apart from the far north of the continent. Population estimates of the species range from 267 million to an incredible 1.7 *billion* individuals.

House finches were actually introduced to the Pacific island group of Hawaii even earlier, from at least the 1870s onwards, probably as birds imported from their native San Francisco. By the start of the twentieth century they had spread to all the major islands, and are now a very familiar sight – and sound – in the capital city of Honolulu.

Hawaii was once home to a suite of unique bird species, many of which have since gone extinct, due to introduced predators such as cats and rats. In contrast, non-native species such as the house finch have thrived. One study of the birds on the University of Hawaii main campus, located in a residential area of Honolulu, found up to fifty pairs. However, breeding success was surprisingly low – perhaps because another introduced species, the house sparrow, steals nesting material from the house finch, and even pecks its nestlings to death.

Incidentally, the red colour of the male house finch comes from carotenoids in its food, which is why some birds are orange or yellow. Females, however, will mate with the reddest male, as this indicates that this bird is able to find the right kind of food for itself and its offspring.

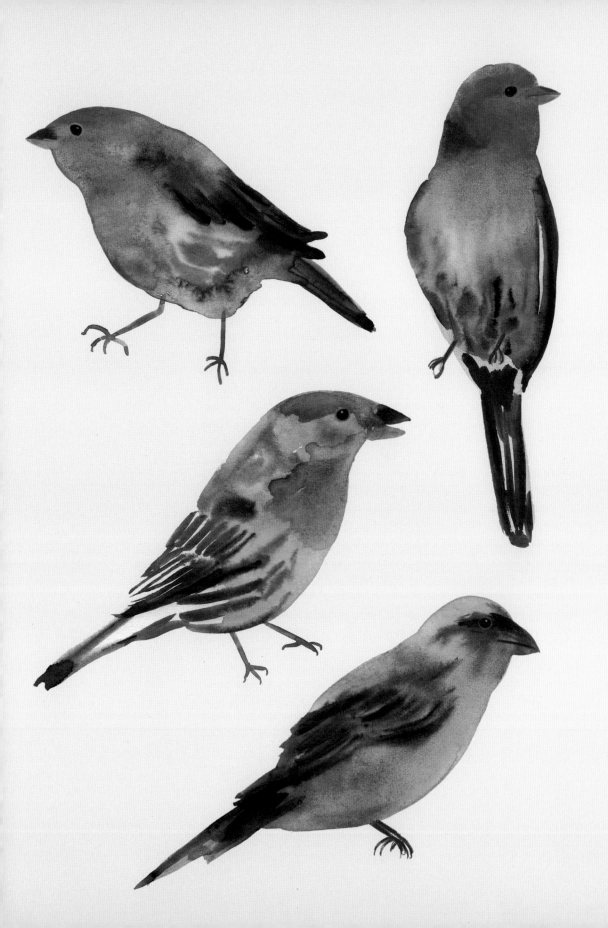

BRONZED COWBIRD

Mexico City, Mexico

19cm (7½in)

33cm (13in)

65g (2¼oz)

Amongst the many colourful and exotic birds found in Mexico City, it would be easy for the bronzed cowbird to go unnoticed.

Along with other members of its family, the bronzed cowbird has an unusual breeding strategy. Just like the cuckoo, it lays its eggs in the nests of other birds, which then do all the hard work in raising the young. It means that female cowbirds can lay far more eggs than most songbirds – up to forty in a single year – something they achieve by producing small eggs that do not require lots of energy. They need to lay such large numbers, because they do not mimic their host's eggs to deceive it and a sharp-eyed host often recognises an egg as not being its own, and ejects it from its nest.

Indeed, in some cowbird species, up to ninety-seven per cent of all eggs laid fail to reach adulthood, yet these species continue to expand in numbers and range, so the strategy must work. The birds are also highly adaptable: unlike some brood parasites, which only choose a handful of birds as their victims, bronzed cowbirds lay their eggs in the nests of more than seventy different species.

About the size of a starling, the male bronzed cowbird is bluish-black, with a subtle bronze sheen on his head and shoulders, hence the species' name. During the breeding season he has red eyes. The female is duller black with browner underparts and brown eyes. In courtship, the male puffs up his neck feathers to form a ruff, said to look as if he has two golf balls stuck in his throat, and also performs ornate courtship flights.

The species can be found from the southern United States, through Mexico and Central America, all the way south to Panama. In recent years, it has become very common and widespread throughout Mexico City, where it can be seen easily in open spaces such as the famous Chapultepec Park, a large area of parkland and woods west of the city centre. Cowbirds are adaptable feeders, taking insects and foraging on seeds, depending on the time of year.

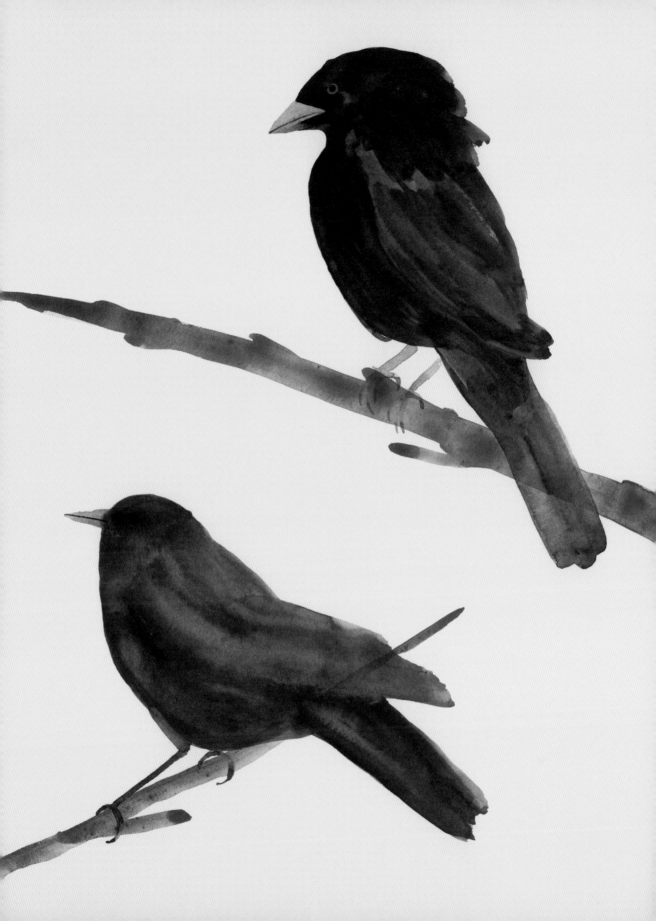

BUFFY-CROWNED WOOD PARTRIDGE
Guatemala City, Guatemala

31.5cm (12½in)

40cm (15¾in)

370g (13oz)

Forest-dwelling gamebirds are some of the hardest birds in the world to see, as they spend their lives hidden amongst the thick vegetation of the tropical forest floor. The population of buffy-crowned wood partridges found in Guatemala City is one notable exception to this rule, as the birds are confident and reasonably easy both to see and to photograph. That makes a visit to the Guatemalan capital essential for any birder who wants to add this elusive species to his or her list.

The buffy-crowned wood partridge is found only in Central America, living in damp montane forests from southern Mexico in the north, through Guatemala, Honduras, El Salvador and Nicaragua, to Costa Rica in the south. It is a member of the New World quail family, which includes the familiar North American bobwhite, along with thirty other species found mainly in Neotropical forests.

These are shy, elusive birds, far more often heard than seen. But visitors to the Parque Ecológico Cayalá, on the eastern edge of Guatemala City, have enjoyed very close views of the birds feeding right out in the open, even on the edge of the car park.

Like other gamebirds, the buffy-crowned wood partridge's plumage is subtle in order for the bird to remain camouflaged against predators. But a close view reveals a bird about the size and shape of a small bantam chicken, with grey and brown plumage streaked with rufous, and a pale creamy throat and face. It also has a short crest, long legs and a prominent, cocked tail. There is an area of reddish-coloured bare skin around the eyes. The female is slightly duller than the male, and her tail is slightly shorter, too.

Buffy-crowned wood partridges are sociable birds, often foraging in small flocks along the edge of forest clearings or in coffee plantations, but generally staying hidden in the undergrowth. Their local name –'chir-ras-qua' – comes from the bird's noisy, whistling call.

Other birds that can be seen in the Parque Ecológico Cayalá, just a few kilometres from the city centre, include the bushy-crested jay, band-backed wren, boat-billed flycatcher and a range of North American migrants such as MacGillivray's warbler, named after a nineteenth-century Scottish ornithologist.

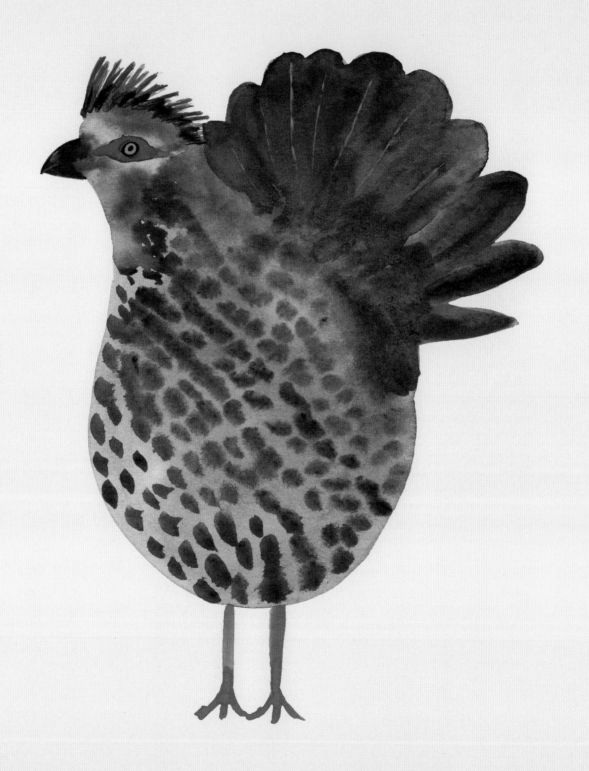

SCARLET IBIS

Port-of-Spain, Trinidad and Tobago

63cm (24³⁄₄in)

54cm (21¼in)

1.4kg (3lb)

Some birds are so colourful that they simply defy belief. One such is the aptly named scarlet ibis, a waterbird found throughout much of tropical South America and the Caribbean, whose plumage is a vivid red shade, apart from black tips to the wings that are fully revealed when the bird takes to the air.

Like all ibises, it has long legs and a long, downcurved bill, which it uses to probe into the mud at low tide for aquatic invertebrates, including ground beetles, crabs and especially shrimps, from which the bird gets its distinctive colour. Adult birds are 63cm (24³⁄₄in) long on average, with a wingspan of 54cm (21¼in), and weigh 1.4kg (3lb). Males are slightly larger than females and have longer bills.

Scarlet ibises have a large range, from southeastern Brazil northwards through Venezuela and Colombia to Trinidad and Tobago, where they are one of two national birds (the other being the rufous-vented chachalaca). On Trinidad, where they are known locally as 'flamingos' because of the superficial similarity in colour, they have become a major tourist attraction. The capital, Port-of-Spain, regularly hosts up to 200 ibises in the city's botanical gardens, and to see the birds in all their glory you can take a trip just outside the city to Caroni Swamp. Each evening thousands of ibises come here to roost from all over Trinidad, watched by boatloads of eager visitors from cruise ships moored in the city harbour. As dusk falls, the birds seem to glow against the night sky, before coming in to land in the trees alongside the water, where they can be safe from predators.

Ironically, given how distinctive a bird the scarlet ibis is, there have been suggestions that it may simply be a colour form of the widespread – and considerably less striking – American white ibis. The two have been known to interbreed regularly, especially in nearby Venezuela, producing peculiar-looking birds with a pale-orange plumage. However, other scientists disagree, pointing to the fact that, across large areas, the two birds' ranges overlap with little evidence of hybridisation.

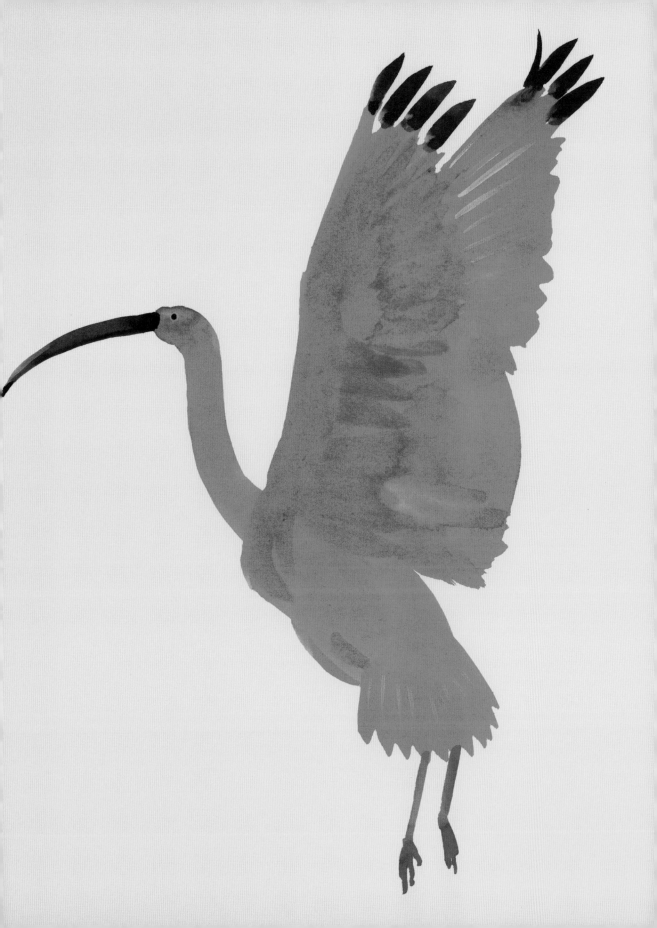

BOGOTÁ RAIL
Bogotá, Colombia

27.5cm (10¾in)

25cm (9¾in)

90g (3oz)

Rails and crakes are notoriously shy and elusive, often hiding away in dense reedbeds or other aquatic vegetation, and only rarely coming into view. In Colombia's capital Bogotá, the eponymous Bogotá rail can sometimes be seen as it emerges for a moment or two, before slinking silently back out of sight.

As its name suggests, the Bogotá rail is endemic to the area in and around the capital city, and is one of the rarest members of its family. The current world population is thought to be fewer than 4,000 individuals, found across a very restricted range of just 11,200 square km (4,300 square miles) – less than one per cent of Colombia's entire land area.

The best place to see these rare and mysterious birds is in the Parque La Florida, alongside the Bogotá River to the northwest of the city, and close to the international airport. Even here, however, sightings are not guaranteed.

The Bogotá rail is superficially very similar to the commoner and widespread water rail, a species found across much of Europe and western Asia. It is also closely related to two American species, the Virginia and austral rails.

Like these birds, the Bogotá rail is very slender, enabling it to pass easily through mainly vertical vegetation. It has short legs, a long neck and long, red bill, which it uses to spear the various creatures on which it feeds. The head and body are lead-coloured (giving the species its scientific name *Rallus semiplumbeus* – from the Latin for lead), while the back and wings are streaked chestnut and black.

In reality, the Bogotá rail should not be an urban bird at all. The reason it is here in the capital is that its preferred habitat – the high-altitude wetlands and grasslands in the Colombian Andes – has been systematically destroyed, and what remains is now under threat from continued development. Like many other rails, it rarely travels long distances and is badly affected by the fragmentation of its existing habitat. So, it clings on here, while conservationists try to halt any further damage and restore wetlands for the species.

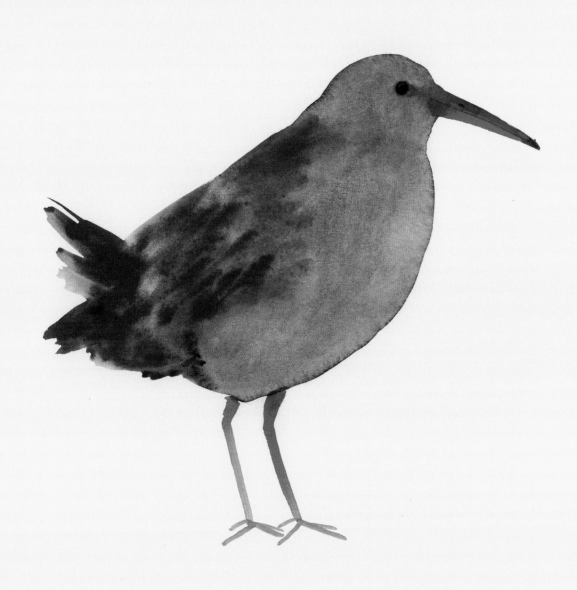

INCA TERN

Lima, Peru

40.5cm (16in)

70cm (27½in)

195g (6¾oz)

Peru is synonymous with the Inca Empire, a civilisation that at one stage, before the arrival of the conquistadores from Europe, was one of the greatest in the world. Today, this lost civilisation lives on in the name of one of South America's most striking and beautiful birds: the Inca tern. At a port and fish market on the southern fringes of the Peruvian capital Lima, Inca terns gather in flocks, perching on the roofs of the buildings and showing off their unique plumage.

Most terns are pale grey and white, but Inca terns are a smart slate-grey in colour, with a black cap and bright reddish-orange feet, legs and bill. A closer look – and the birds are tame and approachable here – reveals a long white plume of feathers on either side of the bill below the eye, reminiscent of the surrealist artist Salvador Dalí's moustache. As if that were not enough, below this, the tern sports the unusual feature of a fleshy yellow gape at each corner of its bill.

Inca terns are confined to the Pacific coast of South America, from Ecuador in the north, via Peru, to Chile in the south. This is also where the cold-water Humboldt Current flows, bringing vast shoals of fish up from southern latitudes, and providing an ideal buffet for the terns and a host of other seabirds.

When fishing, Inca terns glide low over the surface of the sea on their buoyant wings, and then swoop down to grab a fish such as an anchovy. Off the coast of Lima, they are often joined by vast flocks of other species: huge Peruvian pelicans, with their enormous bills, Peruvian and blue-footed boobies (cousins of the gannet) and red-legged and Guanay cormorants.

The terns breed on rocky cliffs up and down this coast, usually nesting in a burrow, where each lays one or two eggs. They incubate their clutch for four weeks, and then feed the growing chicks for a further seven weeks before the chicks fledge and leave the nest.

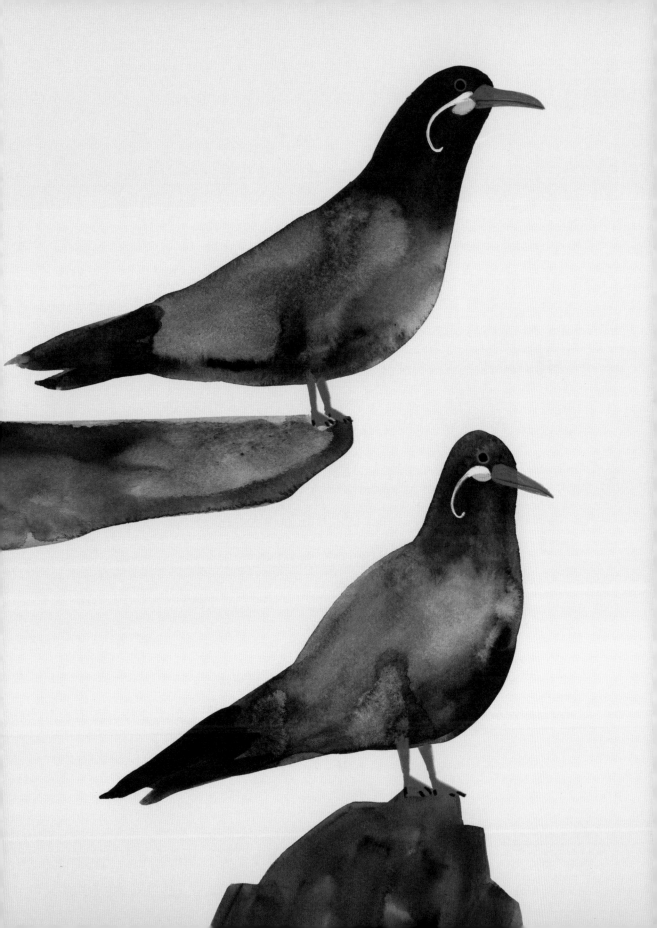

RUFOUS HORNERO

Buenos Aires, Argentina

19.5cm (7¾in)

12.5cm (5in)

50g (1¾oz)

The ovenbirds (also known as furnariids) form a large family of birds found throughout South and Central America. The name comes from the elaborate domed nests built by some members of the family, the shape and appearance of which resemble a clay oven used to fire pots.

The vast majority of ovenbirds are elusive, skulking birds, found mainly in dense, tropical rainforests. But in most bird families there are exceptions designed to prove (that is, test) the rule: in this case, it is the rufous hornero. This thrush-sized bird – whose name comes from the Spanish for 'oven' – is a common sight in urban areas throughout much of South America, including the Argentinian capital Buenos Aires. It draws attention to itself by its bright-rufous plumage and, especially, its loud song, which has helped it become Argentina's national bird.

Like many other songbirds that have adapted well to urban environments, the rufous hornero is a bird of secondary-growth woodland and open pasture. This means that it can easily find a home in the open areas dotted with trees that are characteristic of many South American cities. They can often be seen foraging on grassy areas in parks and on roadside verges, searching for beetles, ants and other invertebrates, which they grab with their long, slightly downcurved bills.

These birds have a tendency to hop into roads – a hazardous occupation given the speed of city drivers – yet they are rarely killed, almost always managing to fly away at the last possible moment. They do, however, have to watch out for predators, especially hawks, snakes and domestic cats.

Rufous horneros not only have a loud song, they also perform a duet between male and female, with the male singing more rapidly than his mate, as both beat their wings in time to their trilling sound. This helps forge the pair bond – most mate for life. They build their large, oven-shaped nests in trees or on man-made structures such as poles and posts. Despite the elaborate nature of the nest, they do not reuse it, and instead build a new structure each spring. Their abandoned nests are often used by other songbirds.

FALKLAND STEAMER DUCK
Port Stanley, Falkland Islands

60.5cm (23¾in)

n/a

3kg (6½lb)

Of all the world's 10,700 or so bird species, just sixty or so – a little over half a per cent – are flightless, having lost the ability to fly at some point in their evolutionary history. Five of these are ducks and include three species in the group known collectively as 'steamer ducks', all of which are confined to the southern part of South America and its offshore islands. They are so named because, when they need to move quickly, they use their wings like paddles on a paddle steamer, flapping them frantically in order to gain speed.

The best known of these birds is the Falkland steamer duck. This large, greyish-brown and white duck is one of only three species that are endemic to the archipelago: the others being Cobb's wren and tussacbird.

The Falkland steamer duck is a familiar sight around the islands' coastlines, and can often be seen in the capital, Port Stanley. Along Port Stanley's waterfront there may be a new territory every few hundred metres.

This is a large and bulky duck: males weigh 3.2kg (7lb) on average – about twice the size of a mallard – though females are smaller, weighing 2.8kg (just over 6lb). This is still well short of the estimate made by Charles Darwin, who claimed that they tipped the scales at a whopping 10kg (22lb).

Falkland steamer ducks are noisy – described as sounding like 'a chorus of bullfrogs' – and extremely aggressive, attacking and even killing birds much larger than themselves. Their only natural predators are southern (also known as Patagonian) sea lions, though they would also have been regular prey for the now extinct Falkland Islands wolf, or warrah. The ducks' ability to run very fast on land was probably an adaptation to enable them to escape from pursuing warrahs.

In January, at the height of the breeding season, non-breeding steamer ducks form large flocks – the highest count from Port Stanley itself being 100. The overall population of the Falkland steamer duck is between 27,000 and 48,000 individuals, so despite its restricted range, the species is not endangered.

MAGNIFICENT FRIGATEBIRD
Rio de Janeiro, Brazil

1m (3¼ft)

2.3m (7½ft)

1.3kg (2¾lb)

With his arms outstretched, the statue of Christ the Redeemer dominates the skyline of Rio de Janeiro, Brazil's largest city. High above, riding the thermal air currents that create lift for soaring birds, the statue's shape is mirrored in the outstretched wings of one of the world's most charismatic seabirds, the magnificent frigatebird.

Frigatebirds – which are related to the gannets and boobies – have the lowest wing loading of any bird. This is the ratio of weight to wing area, and means that, weighing just 1.3kg (2¾lb) on average, a frigatebird can hang effortlessly in the air almost indefinitely, floating on its 2.3-m-long (7½-ft) wings.

It needs to do so because, unlike other seabirds, the frigatebird does not have waterproof feathers. If it lands on the surface of the sea – even for a few moments – it may become waterlogged and drown. Instead, on spotting food on the water's surface, it swoops down and snatches it up with its long bill. For that reason, these birds often follow fishing boats, waiting for fish guts and other waste products to be thrown overboard.

Back in Rio, frigatebirds are a familiar sight as they hang in the air above Sugarloaf Mountain and other tourist sites. They breed on nearby coasts and islands, in large and noisy colonies. Although mostly black, with variable amounts of white on his breast and head, the male frigatebird has a bright-crimson pouch beneath its bill, which he inflates like a balloon during courtship displays, to impress the watching females.

Other names for this species include 'pirate bird' and 'man-o'-war bird', both of which refer to the bird's habit of chasing smaller seabirds and getting them to regurgitate their food, which the agile frigatebird then swoops down to snatch.

Recent studies have shown that frigatebirds can soar as high as 4,000m (13,000ft) above the sea, yet expend almost no energy when doing so, as they rely on the updraughts that occur when clouds form. These usually coincide with upwellings of warm water in the ocean below, which means that these clever birds know that there will be plenty of food.

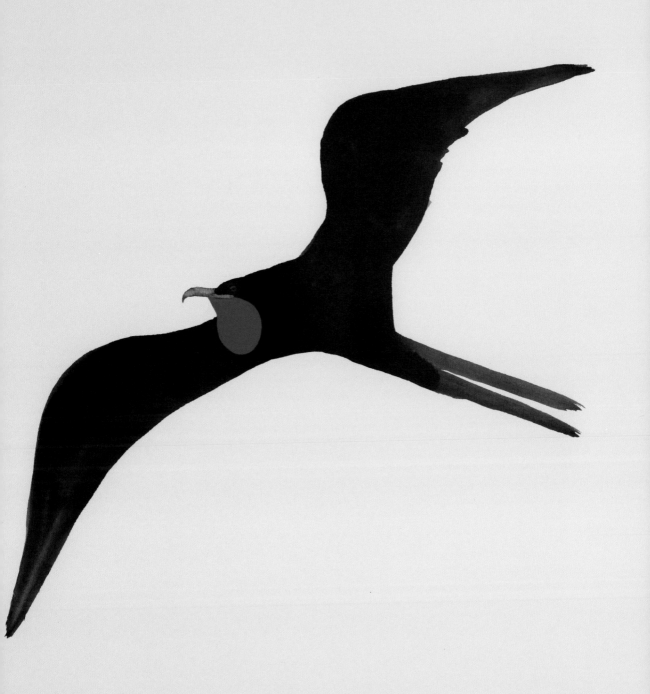

ARCTIC TERN
Reykjavík, Iceland

Terns are legendary for a grace and beauty that is captured in their folk name 'sea swallow', and of all the dozen or so species found in Europe, the Arctic tern is surely the most elegant. With narrow, pale wings, long, forked tails and slender, blood-red bills contrasting with jet-black caps, these birds float like angels in the summer skies – or, as one observer described them, 'gulls that have died and gone to heaven'.

Terns usually nest on offshore islands, where they can be safe from predators, so they are not birds you would expect to see in the middle of Reykjavík. Yet on Vatnsmýrin, a nature reserve in the heart of Iceland's capital, there is a thriving colony of several hundred of these noisy, aggressive birds. Woe betide anyone who ventures inside the nesting area, especially when the terns are guarding eggs or chicks. Both parent birds will dive-bomb intruders, including – further north in their range – polar bears. If one strikes your head with its sharp bill, it is capable of drawing blood.

When not in attack mode, Arctic terns fly around the city in search of food. They catch small fish by diving down into the water, and then take them back to their hungry chicks. They must feed them well; when these little balls of fluff fledge, they will undertake one of the longest journeys across the globe of any living creature. On leaving Iceland in late summer, they fly all the way down to the seas off Antarctica. They spend the autumn and winter there, before flying back north in spring. The total round trip is roughly 32,000km (20,000 miles). In doing so, Arctic terns experience more hours of daylight than any other species on Earth.

A classic sign of spring, Arctic terns are very important to the people of Iceland – they are welcomed back in the same way that returning swallows and cuckoos are elsewhere in Europe. The birds usually arrive in the first week of May, and the first sighting each year appears in Reykjavík's newspapers.

34.5cm (13½in)

80.5cm (31¾in)

105g (3¾oz)

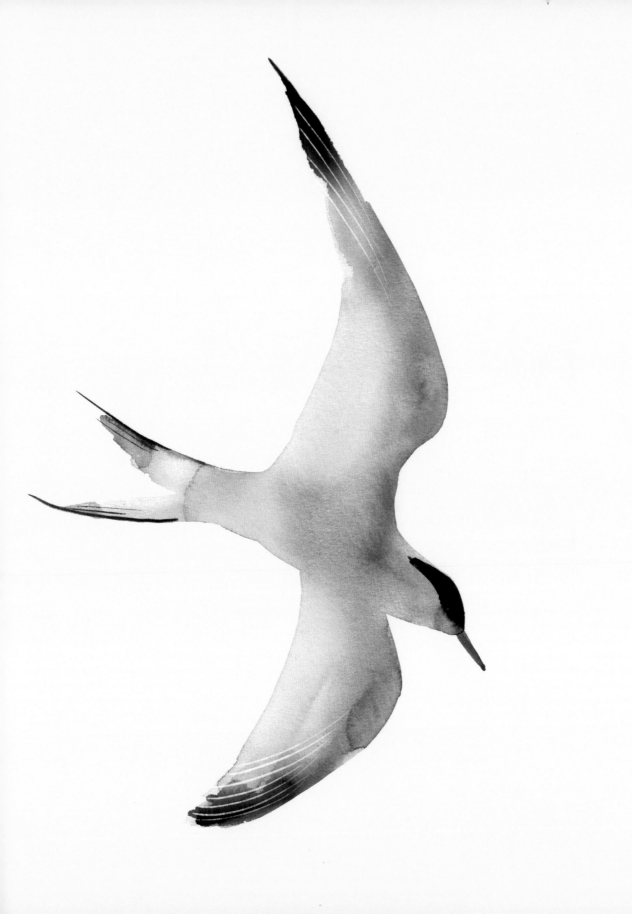

COMMON EIDER
Malmö, Sweden

60cm (23½in)

94cm (37in)

2kg (4½lb)

The common eider is one of the largest and most impressive of all the world's ducks. It is often seen floating offshore, or on rocky islands, in far-flung parts of northern Europe, Asia and North America. But it is also a regular sight in Malmö, Sweden's southernmost city.

Lying on the coast, immediately opposite Denmark's capital Copenhagen, Malmö has been described as 'a fantastic place for urban birding'. This is, in part, because, being so far to the south, the birdlife here is very different to that of other Swedish cities. But the main reason lies in the city's unique geographical location, surrounded as it is on three sides by the sea, which helps to concentrate any birds heading south in autumn or north in spring.

Eiders can be seen here all year round, floating offshore in small flocks, with the largest numbers occurring in early spring. From the second week of March to the middle of April vast flocks pass around the southern tip of Sweden as they head into the Baltic Sea from their wintering grounds in the North Sea. From here, they continue flying north to their nesting places in the Arctic.

At this time of year, birders gather along Malmö's shore to witness the eider movements, but as Swedish birder Erik Hirschfeld has noted, they can be seen just as easily from the city's cafés and ice-cream parlours.

Male and female eiders are very different from each other. The female is mostly brown – essential for camouflage when she is sitting on the nest – but the male is a striking black and white, at least from a distance. Closer up, a pinkish tinge on the breast and a moss-green patch on each side of the neck is easily visible.

Eiders gave their name to the household object, the eiderdown, which traditionally was made from the down (tiny, soft feathers) that the female plucks from her breast in order to line the nest and keep her eggs warm. Today, this is still harvested in places such as Iceland, and fetches high prices, as ounce for ounce it is one of the warmest materials in the world.

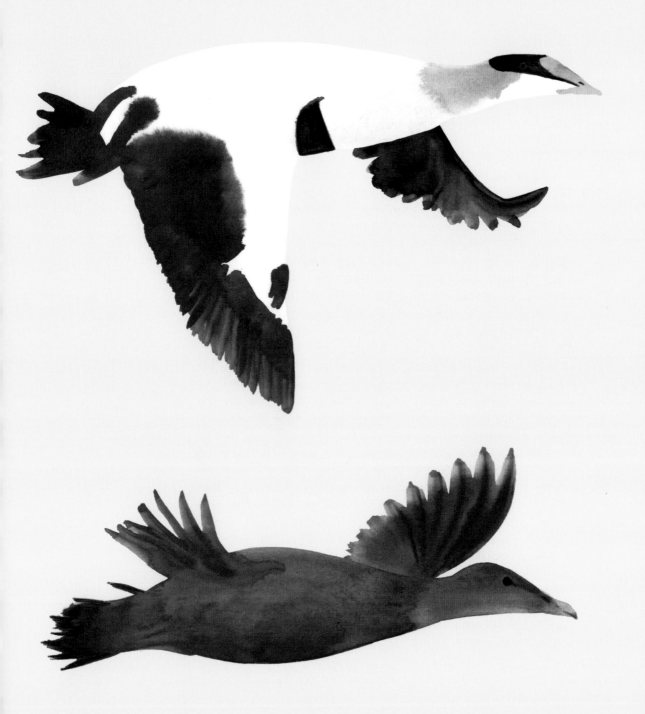

MUTE SWAN
Copenhagen, Denmark

In 1984, the mute swan replaced the skylark as Denmark's national bird, following a vote on a popular TV show. The reason was simple: the Danish public have a great affection for the nineteenth-century children's author Hans Christian Andersen, whose story *The Ugly Duckling* is one of the best-known fairytales in the world.

Mute swans are a common sight throughout the country, not least in the capital, Copenhagen, where they live on freshwater pools and lakes close to the city's harbour and marina. Being Europe's largest bird, measuring roughly 1.4m (4½ft) from beak to tail on average, and weighing up to 12kg (over 26lb), they are happy to live alongside people, whose presence offers them some protection against attack by predators such as foxes. The mute swan's Danish name, *Knopsvane*, literally translates as 'knob swan', and refers to the black protrusion above its orange bill – the male's being slightly larger than that of his mate.

These are long-lived birds; if they reach adulthood they usually survive for another ten years or so. One swan, ringed in Denmark at the age of roughly one-and-a-half years old, in 1970, was found dead in December 2008, meaning that it was at least forty years old – a record for this species.

Almost a century ago, having long been hunted for food and feathers, mute swans had almost vanished from Denmark, with only three or four pairs remaining. Fortunately, the birds have been protected since 1926, and have staged a major comeback. Today, there are at least 4,500 breeding pairs across the country.

Swans have a long history with Copenhagen. From 1611 to 1795, a statue commemorating the Greek myth of Leda and the Swan was a famous city landmark, greeting arrivals at the harbour. When the port needed to be expanded, the statue was taken down. Today, pedalos in the shape of swans are a popular tourist attraction, though it has been observed that the real swans give them a wide berth – perhaps seeing them as extra-large rivals!

1.4m (4½ft)

2.2m (7¼ft)

10.8kg (23¾lb)

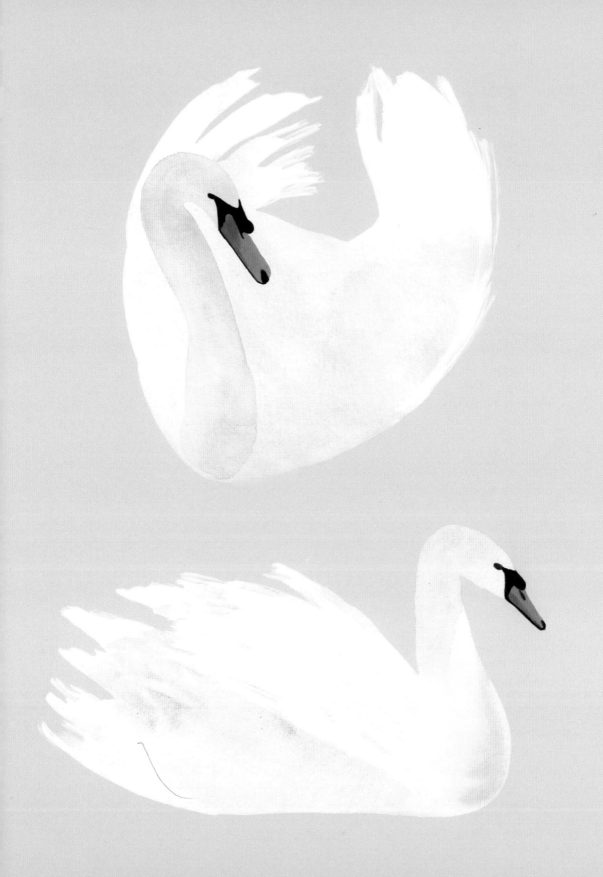

BRENT GOOSE

Dublin, Republic of Ireland

59cm (23¼in)

1.2m (4ft)

1.5kg (3¼lb)

The brent goose is one of the smallest species of goose in Europe, being only about the same size as a mallard. With its dark head, neck and back, white collar and stocky shape, it is easy to identify – though there are at least three different subspecies.

These are the black brant, found in North America; the dark-bellied, which breeds in Siberia and mainly winters in Britain and France; and the pale-bellied, which breeds in Canada and Greenland and of which virtually the whole global population (numbering between 30,000 and 50,000 in total) spends the winter in Ireland. These birds are present from October through to March, before flying back to the far north to breed.

Around the capital, Dublin, pale-bellied brents are found in good numbers, with flocks of up to 1,500 feeding on the mudflats around the city's outskirts. Brent geese feed mainly on Zostera – a marine plant also known as 'eelgrass' – but in recent years the geese have adapted to feed on other grass species, so they are now a frequent sight in Dublin's city parks and sports grounds.

They have become very used to people and even traffic: on one road junction a flock of up to 3,000 pale-bellied brents regularly gathers – as much as one-tenth of the entire world population of this handsome goose.

The brent goose is becoming an urban bird elsewhere in Ireland, with flocks feeding on roadside verges, playing fields and other grassy areas in several south-coast towns. However, they usually only gather here from midwinter onwards, as during the autumn there is still plenty of eelgrass on nearby estuaries.

The pale-bellied brent goose is a major conservation success story. During the 1960s and 1970s the world population fell sharply due to a shortage of eelgrass, at one point reaching a low of just 10,000 birds. But in the past few decades, they have made a comeback, helped by a population boom for lemmings in their Arctic breeding grounds. That's because, during poor lemming years, Arctic foxes and snowy owls turn to feeding on brent goose chicks in their absence.

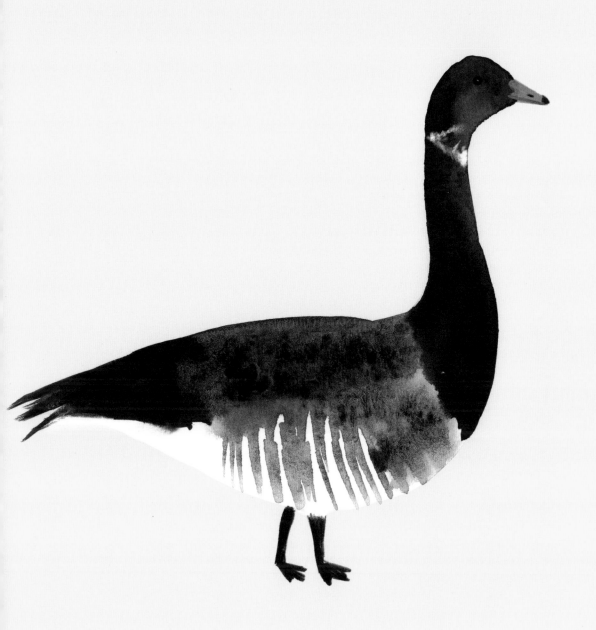

BOHEMIAN WAXWING

Aberdeen, UK

21cm (8¼in)

34cm (13½in)

55g (2oz)

Waxwings are wonderfully unpredictable birds. In some years, tens of thousands cross the North Sea and arrive along the east coast of England and Scotland; in others years, only a handful do so.

That's because waxwings do not make regular migrations, but are an 'irruptive' species. The key to the number of waxwings arriving in Britain is the availability of their favourite winter food of berries in their native Scandinavia. Put simply, if there is a bumper berry crop, they stay put; if the crop is reduced, they head south and west in search of places to feed.

Given their unpredictability, there are few places where you can guarantee to see a flock of waxwings, but Aberdeen is one of them. Rightly described as 'the waxwing capital of the UK', it attracts a few birds even in poor waxwing years; in a good year there may be over a thousand here – including a record count of 1,800 in late 2004.

One unusual characteristic of waxwings is that they are often found in urban areas, especially supermarket car parks. The reason is that these are usually bordered by berry-bearing bushes, which look good and are easy to maintain. These artificial feeding stations provide a bounty for the beautiful birds, which are often so tame they can be approached to within a few metres.

The waxwing is roughly the same size and shape as a starling, with a warm, buffish-brown plumage and a perky crest. Its black-and-yellow wings show a small patch of red that looks like old-fashioned sealing wax (hence the name). They are one of the most attractive of all avian visitors to the United Kingdom, and often attract large crowds of birders.

The best time to see large flocks of waxwings in Aberdeen – and indeed in towns and cities all along the east coast – is in October and November, when they have just arrived. Later they will filter south and west, and may turn up almost anywhere. One bird ringed in Aberdeen was later sighted in the Peak District, Llandudno, Machynlleth and finally north Kent – a trip of more than 1,100 km (700 miles) – before it eventually headed back home to breed the following spring.

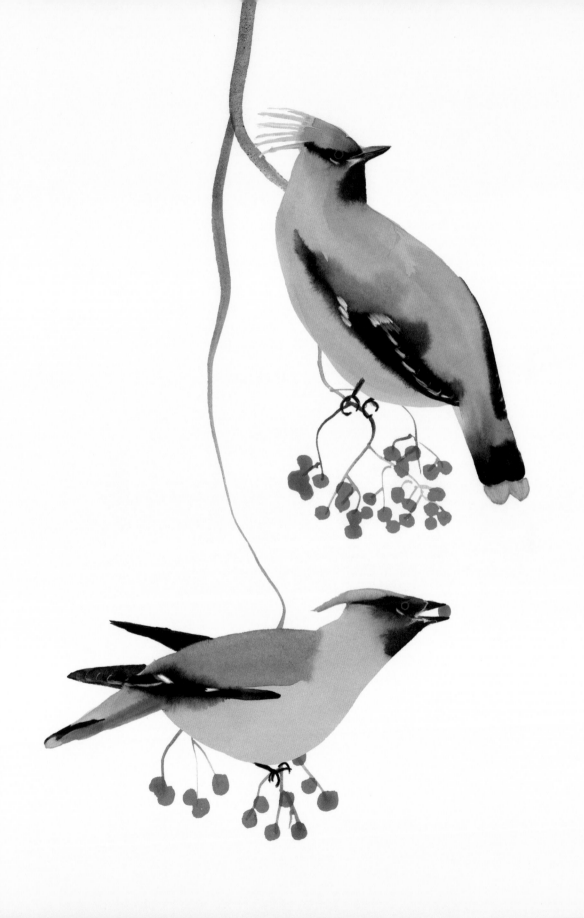

FERAL PIGEON
Glasgow, UK

32.5cm (12¾in)

66cm (26in)

270g (9½oz)

On the remote coasts of northwest Scotland lives a shy, reclusive bird: the rock dove. Confined to rocky, storm-blown cliffs, and feeding on coastal fields, this shy species of pigeon is just about as far from an urban bird as you can get. And yet the rock dove is the original ancestor of all the world's domestic and feral pigeons.

Feral pigeons – also known as city, street, domestic or London pigeons – are a familiar sight in city centres all around the world. From Times Square in New York to Trafalgar Square in London, and the Piazza San Marco in Venice to Dam Square in Amsterdam, large, swirling flocks of pigeons gather around tourists to seek food, despite efforts by the authorities to ban their feeding.

Feral pigeons favour older cities, as they love to nest in holes or crevices in tall buildings. They perform their courtship dance, in which the male circles the female, making soft cooing sounds and puffing up his chest, almost all year round.

In George Square, in the heart of Scotland's largest city, Glasgow, pigeons are a very familiar sight, and are regularly given food by both locals and visitors. Recommendations to visit the square and feed the birds have even been posted on the travel site TripAdvisor, while an article from the early 1980s included a photo of the pigeons being fed by Black Sabbath frontman (later reality-TV star) Ozzy Osbourne.

Glaswegians also interact with pigeons in a traditional ritual known as 'Doo Fleein' – aka 'Dove Flying'. This is a strictly male pastime, in which one man releases a male bird, while his neighbour releases a female. Each man hopes that the birds will mate, and then return to his own dovecote, on which he becomes the owner of both birds.

Whether feral or domestic, all urban pigeons must be wary of a newcomer in their midst. Peregrines have enjoyed a population boom in recent decades, and so have moved into our cities, where plentiful pigeons are one of the main items on the menu.

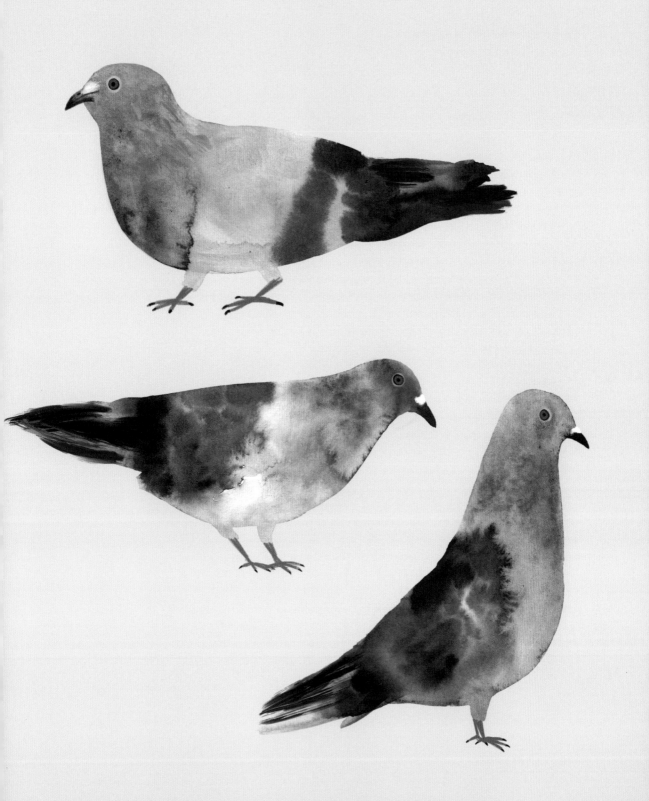

BLACK-LEGGED KITTIWAKE
Newcastle, UK

The city of Newcastle is famous for many things: its celebrated brown ale; the football club – complete with avian nickname, the Magpies; and the sing-song Geordie accent. Now it has a new claim to fame as the home of the most inland breeding colony of kittiwakes in the world.

39cm (15⅓in)

94cm (37in)

410g (14½oz)

The black-legged kittiwake is a small, neat and rather attractive member of the gull family, with dove-grey and white plumage and wingtips that look as if they have been dipped in ink. Unlike their relatives, which have adapted to a life inland, kittiwakes are known for their ocean-going habits. Traditionally, they come to land to breed for just a few months, building precarious nests on narrow ledges along sea cliffs, before heading back out into the open ocean where they spend the autumn and winter months, far from land.

A few years ago, a small group of kittiwakes decided to head upriver and nest on the ledges of a disused flour mill overlooking the River Tyne, right in the city centre and more than 12km (7.5 miles) from the sea. They were successful, raising their chicks on food snatched from the river's waters, and the colony boomed. When they outgrew the space on the original building (which by then had been turned into an arts centre), they simply moved onto the famous Tyne Bridge itself. Today, up to 800 pairs breed on the bridge and surrounding buildings – on narrow ledges that perfectly mimic their natural habitat.

The kittiwakes are not universally popular amongst the city's residents and businesses. They do, it's true, make a mess with their droppings, and the loud call from which the bird gets its name has been the subject of complaints. At one stage, a local hotel group even tried to dissuade the birds from nesting by using electric shocks. Spikes were also temporarily installed to deter them.

After protests from local people, many of whom regard the kittiwakes as a welcome addition to city life, the protesters backed down and it now looks as if these charismatic birds are here to stay.

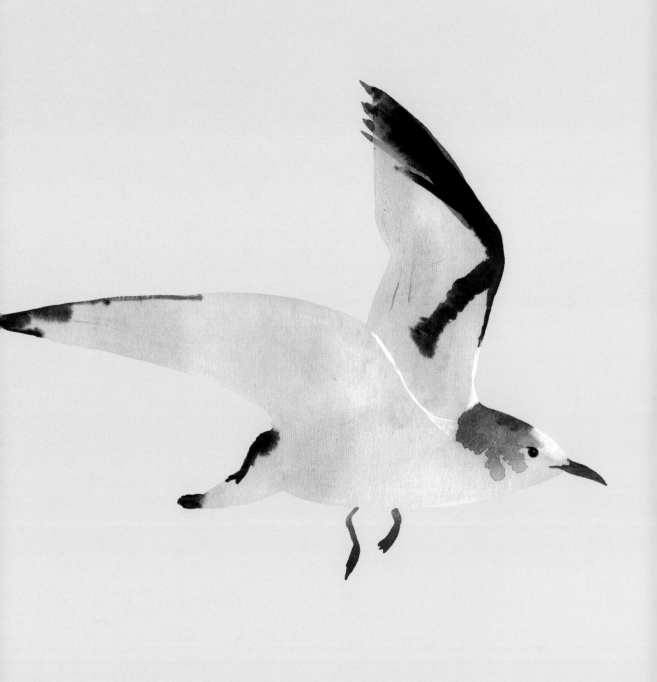

PIED WAGTAIL

Manchester, UK

The pied wagtail – the British subspecies of the widespread Eurasian species, the white wagtail – is a common and familiar sight on city streets throughout much of the United Kingdom. The birds feed on tiny insects, which they find by foraging on pavements, roadside verges and grassy areas, where most other birds do not bother to feed.

17.5cm (7in)

28cm (11in)

21g (³⁄₄oz)

Mostly solitary or in twos or threes during the day, and in pairs during the spring and summer breeding season, pied wagtails become highly sociable on autumn and winter evenings, when they gather in flocks of up to several hundred birds to roost for the night.

Greater Manchester is famed for its nightlife and, perhaps surprisingly, many of the wagtail roosts are at familiar local landmarks. Piccadilly Gardens, right in the city centre, is home to a roost of well over 200 wagtails, which often gather in a sycamore tree next to the famous statue of the Duke of Wellington.

Others can be found around bingo parlours and nightclubs, car parks, shopping centres, traffic lights, hospitals and restaurants. What all these unlikely places have in common is that they are well illuminated, noisy and full of people. That doesn't bother the pied wagtails at all – in fact they welcome it, as noise and light keep predators such as tawny owls at bay.

The first sign of these birds is usually at dusk, when passers-by may hear a soft, twittering sound, or the loud 'chis-ick' calls of the birds as they arrive. As more and more birds gather, the sound rises to a crescendo, each bird trying to find the best place to spend the night. Gradually, however, the sound begins to drop, and soon afterwards all the birds huddle up together and fall asleep – despite the hustle and bustle of the city going on beneath them.

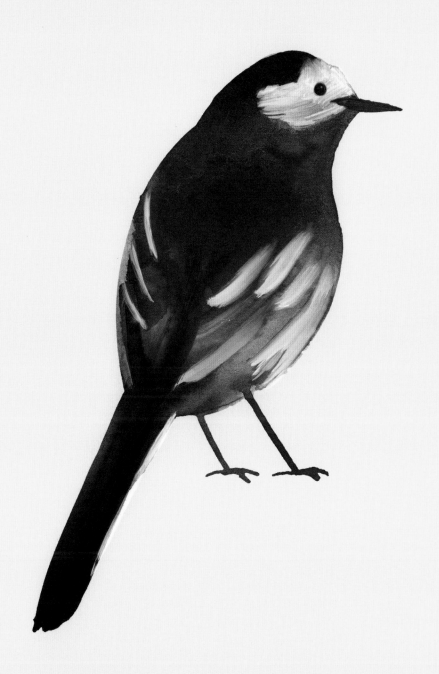

BLACK REDSTART

London, UK

Walking through the centre of London, perhaps the last thing you might expect to hear is one of Britain's rarest breeding birds. Yet cutting through, above the noise and bustle of the city traffic, is the short, rather metallic-sounding song of the black redstart.

What makes this even more extraordinary is that, had it not been for the extensive bomb damage caused by the Second World War Blitz, this relative of the robin would not be in London at all.

The name 'redstart' comes from an Anglo-Saxon word meaning 'red tail' and, like its woodland cousin the common redstart, this species has an orange-red tail and hindquarters. As its name suggests, the bird also has a sooty crown, back and underparts, a black face and throat and, to set these dark areas off, prominent white flashes on its wings, which are revealed when the bird takes flight. This is a perky little bird, rather like a slim version of the familiar robin.

Until the 1940s, the black redstart was a very rare visitor to Britain from continental Europe. Breeding on occasion, it had never succeeded in colonising permanently. Following the destruction of thousands of buildings in Second World War bombing raids, however, the derelict bombsites that were left behind provided the ideal home for these birds.

In the rest of Europe, the black redstart is a bird of rocky or mountainous areas, often close to towns and villages. The species has adapted to feed on tiny insects that live in cracks and crevices, which other birds fail to exploit. London's bombsites were remarkably similar to the black redstart's seminatural habitat, and the species soon colonised them.

These areas were rebuilt eventually, but the black redstart simply relocated to building sites, industrial areas and even power stations – places in which few small birds can survive, yet ideal for this species. In autumn and winter, black redstarts often head south to the coast, where the weather may be milder and there is more food. But in early spring they return, to raise their families in the heart of one of the world's busiest cities.

14.5cm (5¾in)

24cm (9½in)

15g (½oz)

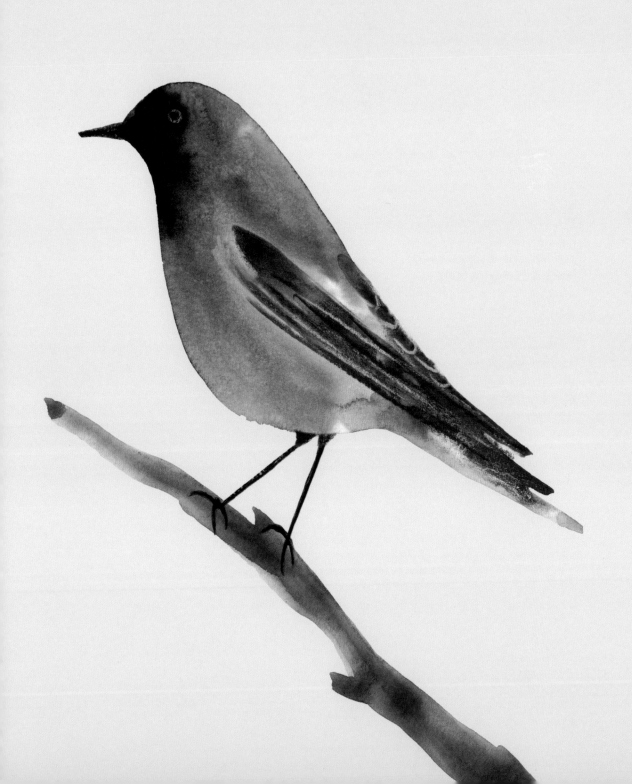

HOUSE SPARROW

London, UK

16cm (6¼in)

24cm (9½in)

30g (1oz)

Few birds are associated with one particular city as closely as the house sparrow is with London. The phrase 'cock sparrer' has long been used as an affectionate greeting in the UK's capital, and was even adopted as the name of a little-known, but once influential, punk-rock band.

Sparrows used to be so common in London's parks that one old gentleman would regularly feed them by hand, encouraging passers-by and tourists to follow his example. In 1925, when the young ornithologist Max Nicholson surveyed the birds of Kensington Gardens, he counted no fewer than 2,600 house sparrows – more than half the total number of birds living there. Seventy-five years later, at the turn of the millennium, the nonagenarian Nicholson returned to do a recount: this time he found just eight sparrows. Today, there are none.

Indeed, apart from tiny colonies at the Tower of London and London Zoo, there are now virtually no house sparrows living in central London at all. So, what has caused this calamitous decline?

Sadly, we still do not know exactly why London's sparrows have disappeared. Some point the finger at urban development: the relentless urge to 'tidy up' the messy corners in which the sparrows once thrived. Others – including the eminent ornithologist (and former industrial chemist) Denis Summers-Smith – suggest that vehicle exhaust fumes are to blame. If so, then the sparrows are the modern-day equivalent of the 'miner's canary', warning us of the perils of air pollution.

The recent fall in sparrow numbers has one silver lining: few of us now take this cheeky little bird for granted, as we once used to. A closer look at this classic 'little brown job' reveals a subtle beauty: the male, in particular, is a very handsome bird, with his combination of brown, buff and chestnut plumage, grey crown and smart, black bib.

Moves are afoot to encourage house sparrows to return to London, by providing specially designed communal homes for these sociable birds. Unless the root cause of their decline can be reversed, however, it is unlikely that sparrows will ever be as common as they once were on the streets of the capital.

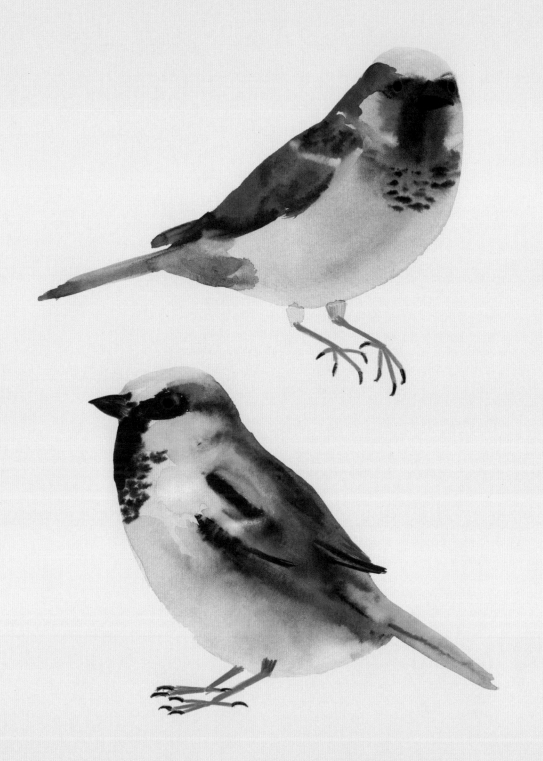

HERRING GULL
Bristol, UK

Seagulls are meant to be just that: gulls that spend their lives by the sea. And none are more quintessentially linked with the British seaside than the herring gull, whose ringing call has long been familiar to holidaymakers.

61cm (24in)

1.4m (4½ft)

1kg (2¼lb)

Yet, today, the herring gull is on the Red List of Birds of Conservation Concern. Numbers are falling, especially at coastal sites where they once thrived. The reason is simple: a fall in the numbers of fish and changes in fishing practices, with less thrown overboard than before, mean that there is simply less food available.

The good news – for the gulls at least – is that many have found new homes in Britain's cities, especially in London, Cardiff, Bath and Bristol. Home to the BBC Natural History Unit, Bristol has long had a deserved reputation as one of the greenest and most wildlife-friendly cities in Britain. However, the patience of the locals is being sorely tested by the gulls, which are always on the lookout for food, and even sometimes snatch it from the hands of unwary humans.

In fact, the reason that gulls have moved into the city is not so much to do with food as with accommodation. Bristol's herring gull – along with its cousin the lesser black-backed gull, which has a darker back and wings – nests on the tops of buildings. Here they are almost completely safe from predators, so are able to raise two or three young each year. As a result, the city's gull population has skyrocketed.

It's often said that urban gulls survive mainly on takeaway food, dropped by careless revellers on Saturday nights. Actually, this makes up only a small part of the bird's diet. Instead, flocks of gulls regularly travel north of the city to a landfill site near Gloucester, where they can gorge to their hearts' content on our waste.

So perhaps we can blame the boom in urban gull populations on our consumer society. Or we can take a different view: that these fascinating and intelligent birds bring a new dimension to city life, and should be welcomed rather than reviled.

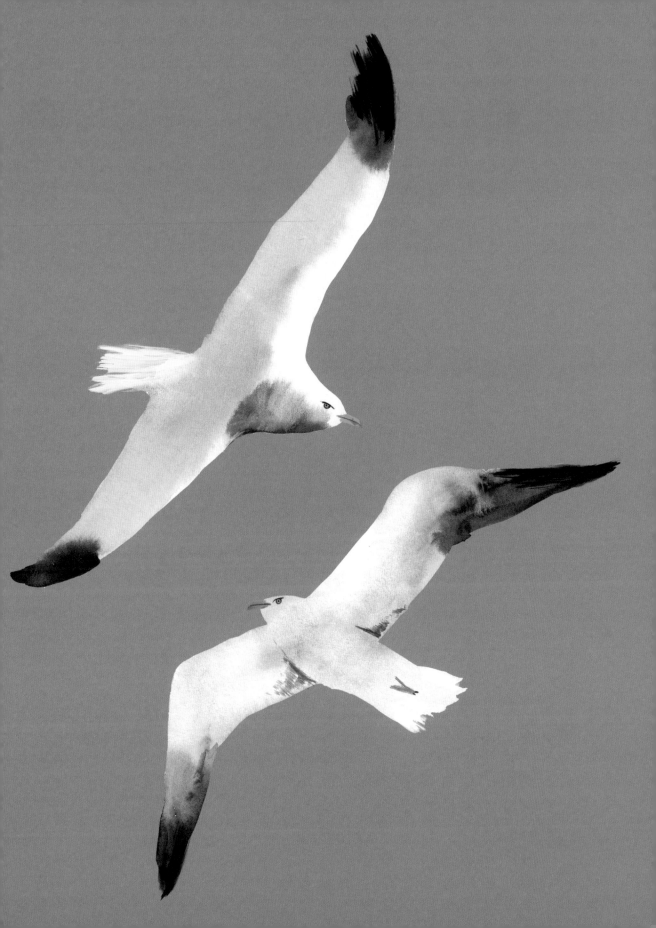

MONK PARAKEET
Barcelona, Spain

The Catalan capital of Barcelona is now home to seven different species of feral parrot, of which the commonest is the monk parakeet. Named for its pale-grey head and neck, which resembles a cowl worn by medieval monks, this is the only one of the world's 380-plus kinds of parrot that does not nest in a hole in a tree or in the ground. Instead, the monk parakeet makes a vast structure out of twigs, in which the female lays up to a dozen eggs.

Originally found across much of South America, monk parakeets were brought to Europe as cage birds. Many escaped, and formed feral, self-sustaining populations in a number of cities, including Barcelona. The combination of plenty of food and a benign climate all year round has enabled them to prosper and today there are at least 10,000 monk parakeets living in the city.

Flocks of these gregarious birds may be seen – and heard – anywhere in the urban centre and suburbs, though the best places to see them are in the city's parks. They also frequently visit gardens. They mostly feed on fruit, berries and nuts, varying their diet from season to season. The parakeets time their breeding season to coincide with the greatest abundance of food, so nest late, from August to November.

Charles Darwin was the first person to observe that, in their native home, monk parakeets can be major agricultural pests, feeding on fruit in orchards. So far this is not a serious problem in Europe, but it may become so as numbers continue to rise. There have been cases of parakeets building their nests on utility poles and pylons and causing power blackouts and fires. They may also be damaging trees, and there have been calls to have the birds culled.

As with ring-necked parakeets in London, monk parakeets often fall victim to peregrines. In Barcelona, this is especially the case with the pair that nests on the famous Sagrada Família.

Genetic studies of Barcelona's monk parakeets have revealed that the entire population descends from birds from a single area in and around Uruguay, meaning that they have a very low genetic diversity. This could cause them problems with disease in the future.

29cm (11½in)

49cm (19¼in)

115g (4oz)

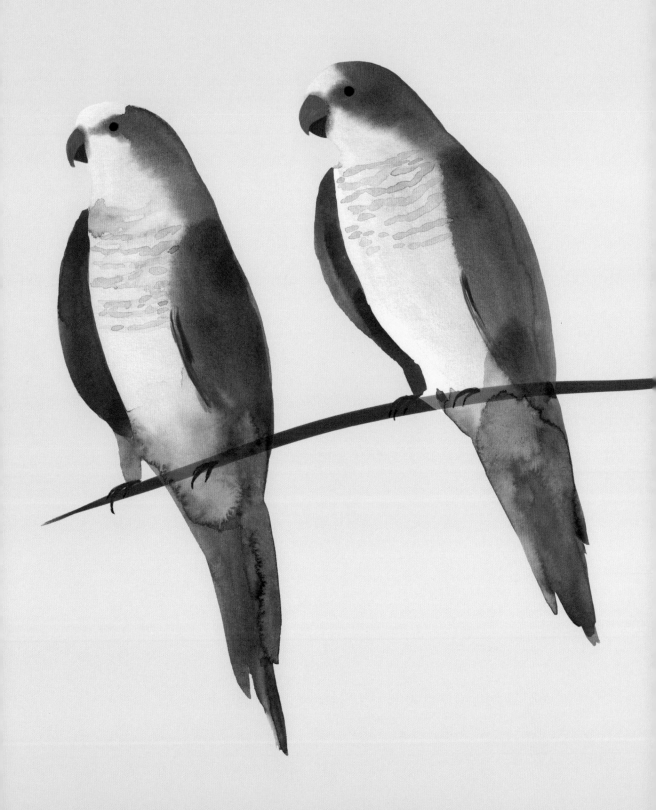

PEREGRINE

Barcelona, Spain

Visitors to Spain's second city and Catalonia's capital, Barcelona, are attracted by a wealth of tourist sites of which the most famous is the Sagrada Família, a vast Roman Catholic church that towers above the city skyline.

43cm (17in)

96.5cm (38in)

920g (2lb)

The church was designed by the early-twentieth-century architect Antoni Gaudí and building work began in 1882. Over forty years later, when Gaudí died, the church was still not finished. Astonishingly even now it is not fully complete, although it is due to be so on the centenary of the architect's death in 2026.

This does not seem to bother the millions of tourists who flock to the site each year; nor does the building work affect the church's highest residents, peregrines, a pair of which regularly nests on the structure, the birds perching on its highest pinnacles to survey the city below.

Peregrines are one of the world's largest falcons, a female tipping the scales at 1.1kg (2½lb) on average, with a wingspan of over 96.5cm (38in). But the peregrine's real fame comes from its speed, which sees it plummeting after prey at up to 389kmh (242mph). Peregrines hunt birds, which means that cities such as Barcelona offer a tempting buffet of food available at any time of day or night, and throughout the year. Pigeons are a key prey item, but Barcelona's peregrines also take monk parakeets, the feral South American parrots that thrive in the city.

Peregrines bred regularly in Barcelona until the early 1970s, when they disappeared because of the use of agricultural pesticides such as DDT and persecution by racing-pigeon enthusiasts. In 1999, it was decided to reintroduce them into the city, and almost fifty birds were released. The project was a huge success, and now the peregrine is firmly established as an urban bird in Barcelona.

Urban peregrines here and elsewhere have changed their behaviour to suit the twenty-four-hour nature of city life. At night, aided by the lights used to illuminate famous buildings such as the Sagrada Família, they hunt migrating birds as they pass overhead – a striking example of how urban birds can adapt to new surroundings.

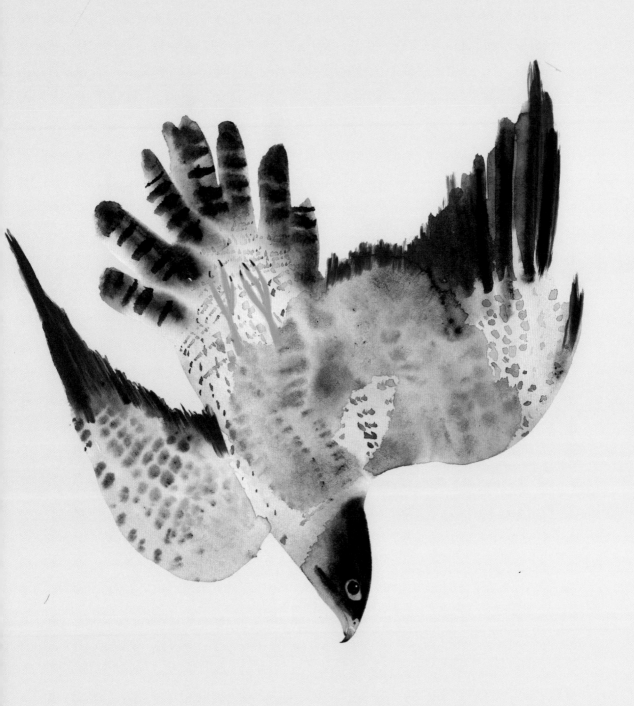

SPANISH IMPERIAL EAGLE

Madrid, Spain

79.5cm (31¼in)

2m (6½ft)

3kg (6½lb)

In 1974, the Spanish imperial eagle – one of Europe's largest and most majestic raptors – was on the brink of extinction, with just fifty pairs remaining in the world, all in southern Spain.

Today, less than half a century later, this impressive bird of prey is now secure, thanks to the dedicated efforts of Spanish conservationists to protect the eagles and their habitat. There are now estimated to be almost 1,000 birds, of which around thirty pairs breed in the province of Madrid, Spain's capital city. They can often be seen soaring over Monte de El Pardo, a wooded area just north of the city, where up to nine pairs breed. As a result of its comeback, the species was voted the area's favourite bird by the organisation Birdwatching Madrid.

This is a truly magnificent bird. With a length of 79.5cm (31¼in) on average, a wingspan of more than 2m (6½ft) and weighing roughly 3kg (6lb), it is larger than all other European raptors apart from vultures and the golden and white-tailed eagles. Imperial eagles live in a range of habitats, including Mediterranean forests, marshes and 'dehesas' (lightly wooded pasture typical of southwest Spain and Portugal). They feed mainly on rabbits, although, like other large raptors, they will take most birds or mammals they can catch, and will also scavenge carrion. The breeding process is long and slow: the female lays between one and four eggs, which are incubated for six weeks; the youngsters then stay in the nest for seventy-five days after hatching.

Adult eagles are sedentary, remaining in their territories all year round. However, youngsters often wander away from their parents' home range, when they are likely to be seen closer to Madrid's city centre. These are long-lived birds, and slow to reproduce, first breeding when they are four or five years old. They build their nests on tall trees, although some birds use electricity pylons. Sadly, one of the main causes of death for Madrid's eagles is electrocution, while others fall victim to poisoning. Overall, nine in ten deaths are due to humans, yet this mighty raptor is still managing to survive on the edge of an urban environment.

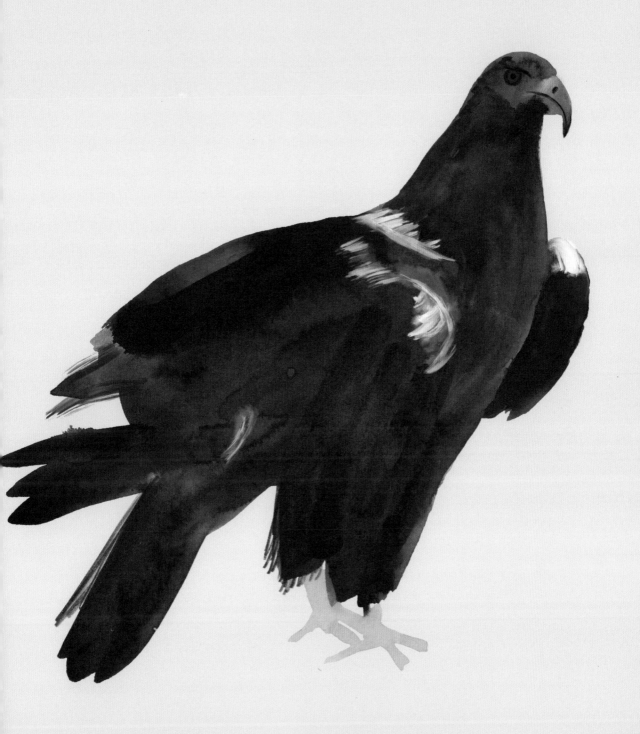

LESSER KESTREL
Seville, Spain

30.5cm (12in)

65.5cm (25¾in)

150g (5¼oz)

The Spanish city of Seville is home to one of the world's largest and most impressive cathedrals, the sixteenth-century Saint Mary of the See, built on the site of an even older mosque. For visiting birders, this 100-m-high (328-ft) edifice is also home to one of Europe's rarest and most graceful birds of prey: the lesser kestrel.

As the diminutive falcon's name suggests, this bird is the smaller cousin of the much commoner kestrel, one of Europe's best-known raptors. The male has a grey head, orange-brown back and black tips to the wings and tail, while the female is mainly barred brown and black.

Roughly the size and weight of a medium-sized dove, with rounded wings and a long, narrow tail, the lesser kestrel is able to float through the skies high above the city, looking down in search of lizards and small birds, on which it feeds itself and its young. Unlike most other raptors, these are sociable birds, often hunting in flocks of several dozen, hawking together for flying insects in the warm summer skies.

In Seville, a thriving breeding colony of about seventy pairs of lesser kestrels nests on the cathedral, the birds often perching on the famous bell tower, the Giralda. The lesser kestrels use this tower as a lookout post, from which they can survey their aerial territory below.

Unlike most species that come out in daytime, lesser kestrels also hunt by night, taking advantage of the powerful lights that illuminate the cathedral once darkness falls. The light beams enable the birds to hunt for moths, which are also attracted to the lights, and take the occasional small bat, in turn attracted by the large numbers of moths.

Each autumn, when lower temperatures reduce the availability of flying insects, lesser kestrels head south to spend the winter in Africa, mostly south of the Sahara desert. They return early in the year – usually in February – to prospect for nest sites on the cathedral and surrounding buildings. Elsewhere in Spain, they can also be seen in several other cities, including Cáceres and Trujillo in Extremadura.

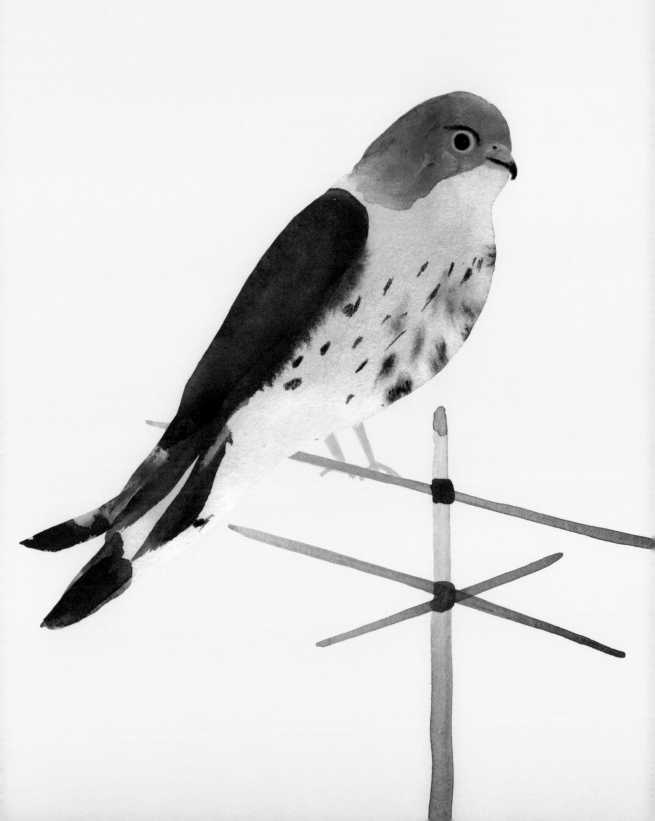

SHORT-TOED TREECREEPER

Paris, France

Paris is a city known for its leafy, green, wooded areas, most famously the Bois de Boulogne – which, at over 800 hectares (2,000 acres), is well over twice the size of New York's Central Park – and Le Parc de l'île Saint-Germain, an island in the River Seine close to the centre of the French capital.

12.5cm (5in)

18cm (7in)

9g (⅓oz)

Like all urban green spaces, these places become very crowded with joggers, dog walkers and commuters, but on an early-morning visit in spring, you can enjoy the dawn chorus, and amongst the usual calls of blackbirds, thrushes and robins, the thin, high-pitched song of the short-toed treecreeper is just about audible.

The treecreeper – as its name suggests – spends its life exclusively in wooded habitats. It feeds by creeping up and around tree trunks and larger branches, using its thin, downcurved bill to search for the tiny insects on which it feeds all year round. Small, brown above and white below, it is often mistaken for a small mammal rather than a bird, because of its jerky movements.

Two of the world's thirteen species of treecreeper are found in Europe, and both can be seen in France. The short-toed and Eurasian treecreepers are very hard to tell apart, as the shorter toes of the former species are not visible in the field. The best way to distinguish them is usually by listening to their songs. However, the Eurasian treecreeper is more often seen in upland areas, especially those with coniferous forests, whereas the very similar, short-toed treecreeper prefers deciduous woodlands in lowland areas – hence, this is the one found in Paris.

Paris's parks boast other woodland birds, including black, middle spotted and lesser spotted woodpeckers, hawfinches and crested tits. Of all these special birds, the short-toed treecreeper is the most unobtrusive, rarely drawing attention to itself, though it can be very tame in the presence of people – young treecreepers have been known to crawl up human beings, presumably mistaking them for trees! These birds are generally solitary, but will roost communally in cold spells during the winter months, using one another's body warmth to stay alive.

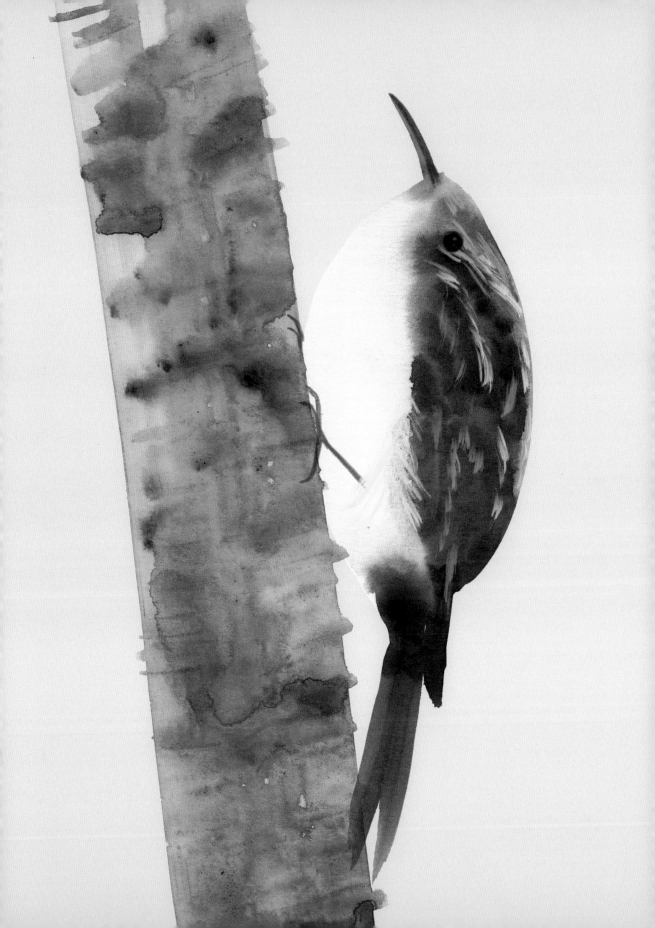

GREATER FLAMINGO
Montpellier, France

1.3m (4¼ft)

1.5m (5ft)

3.1kg (6¾lb)

The city of Montpellier lies on the French Riviera, just west of the famous marshes of the Camargue, one of Europe's great wildernesses. The Camargue is one of the few remaining places in Europe where this tall and colourful waterbird breeds, with up to 25,000 nesting pairs.

In July, once the breeding season is over, the birds disperse to feed along the Mediterranean coast. From then until October, up to 1,500 flamingos can be seen in Montpellier – a significant part of the European population. Some stay all the way through the winter to the spring, though soon afterwards, most head back to the Camargue to breed.

The flamingos have become a major tourist attraction, and are even mentioned in lists of 'things to do in Montpellier'. They can be seen from the city's famous trams, as these pass alongside the lagoons on the outskirts of the city.

Despite the good numbers of flamingos seen here, the species is on a knife edge. Unless the pH of the water is exactly right where they nest, any breeding attempts usually fail; floods or droughts can also cause problems.

The greater flamingo is, as its name suggests, the largest of the world's six flamingo species, and the only one found in Europe. It stands 1.3m (4¼ft) tall on average, with a wingspan of 1.5m (5ft). The bird is mainly very pale pink in colour (which comes from the brine shrimps it eats), with darker orange-pink and black on the wings and very long legs. It feeds, like all flamingos, by inverting its head and filtering water through its bill to catch the tiny crustaceans.

Flamingos are such striking birds, it's hardly surprising that they feature in myths, legends and literature. The ancient Egyptians regarded them as an incarnation of Ra the sun-god, while the Romans famously consumed their fleshy tongues in vast quantities at banquets. Later, Lewis Carroll featured a flamingo as a croquet mallet in *Alice's Adventures in Wonderland*, while in and around Montpellier, the flamingo features in branding for bars, restaurants and casinos.

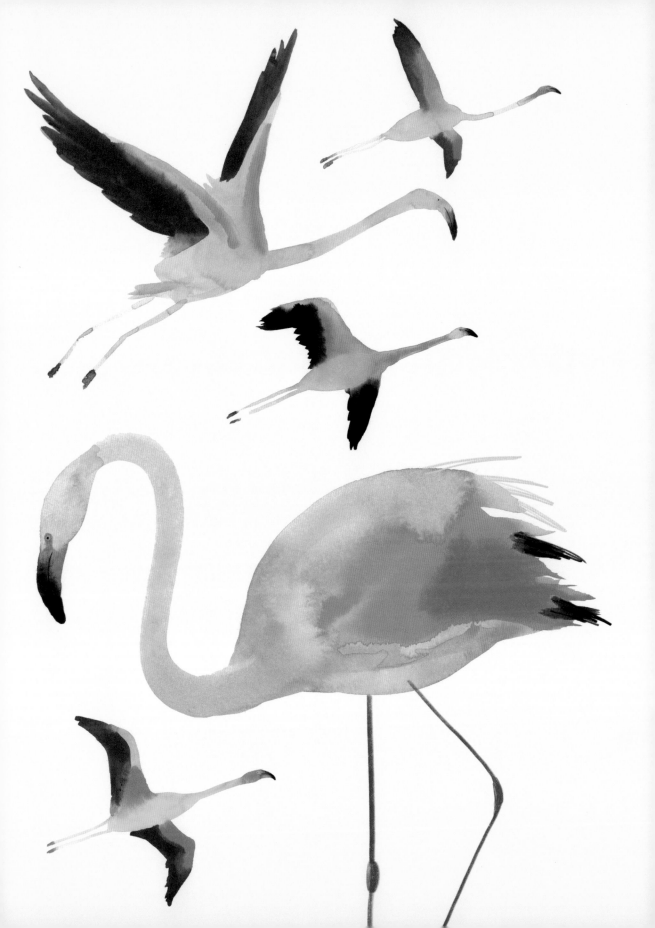

GREY HERON

Amsterdam, The Netherlands

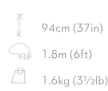

94cm (37in)

1.8m (6ft)

1.6kg (3½lb)

Few birds are such expert anglers as the heron, and with its long, dagger-shaped bill, the grey heron is one of the best of all at catching fish. Unlike many waterbirds, however, which tend to live in large, open wetlands, grey herons have adapted well to city life. Throughout their European range, they can often be seen standing alongside urban rivers and canals, patiently waiting to strike at their prey.

The Dutch city of Amsterdam is famous for its network of canals, and herons are not an uncommon sight here. These waterways are clean and well stocked with fish, while the constant throng of people on foot and bicycles means that predators are few and far between.

Herons are early breeders, building their huge, untidy nests out of twigs in the tops of trees; again, Amsterdam has plenty of suitable locations for them, with roughly 800 pairs nesting in twenty-five colonies in the local parks.

The people of Amsterdam have mostly taken the herons to their hearts, often giving them a helping hand by feeding them with fish, while the birds also gather at open-air markets. This enables them to survive during spells of harsh winter weather, when herons in rural areas can be very vulnerable, as they are unable to feed through a layer of ice.

At one café, locals run a contest to see how many herons they can capture in a single photograph – the current record stands at twenty-nine. Given that, apart from when they are nesting, herons are usually solitary in their habits, this comes as a surprise.

Herons regularly visit the city zoo, to take advantage of the fish provided for penguins, otters and seals – though one unfortunate bird was caught out and killed by the zoo's resident lion.

Not everyone loves these piscatorial predators. Some homeowners, especially those with garden ponds, resent the way the birds eat all their precious ornamental fish. But most of Amsterdam's citizens – and the millions of visiting tourists – enjoy watching the herons as they wait patiently to catch their prey.

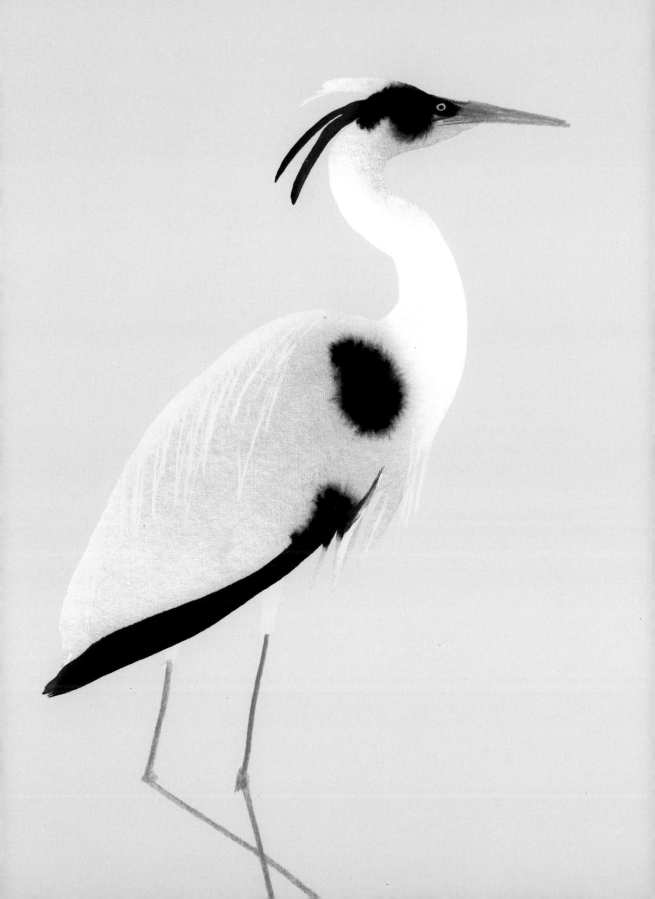

EURASIAN BLACKBIRD
Groningen, The Netherlands

The blackbird is not only one of the commonest of all European birds, it is also one of the most familiar. Breeding in every European country except Iceland, and east across Asia to southeast China, it is one of the world's most adaptable species, able to live in any habitat with trees. Like many common woodland birds, it has also adapted very well to living in cities. In the north of the Netherlands, the historic city of Groningen is ideal for blackbirds, having plenty of leafy parks and gardens that mimic the woodland-edge habitat of this species.

The male blackbird lives up to its name, being black with a yellow bill and a gold ring around each eye. Females and youngsters are mostly brown in colour, with variable buff and dark spotting in the breast, and can sometimes be mistaken for thrushes.

Groningen, and cities like it, offer a number of advantages to the blackbird. First amongst these is the urban heat-island effect, which allows urban blackbirds to begin nesting far earlier than their rural counterparts. As this species can have at least three, and as many as five, broods a year, this is a significant benefit. Food is more reliable in cities, too, as in winter people often feed the birds in their gardens. As a result, city blackbirds tend to live longer than their country cousins.

However, in recent years, scientists at the University of Groningen have discovered that city life may not be quite as good as was thought. They compared the health of urban blackbirds with their counterparts in nearby forests, specifically focusing on telomeres, the sequences of DNA that form a protective barrier on each of the bird's chromosomes. This showed that blackbirds living in the city had significantly shorter telomeres, indicating that these birds were more stressed than those in a more natural, wooded habitat.

 25.5cm (10in)

36cm (14in)

95g (3¼oz)

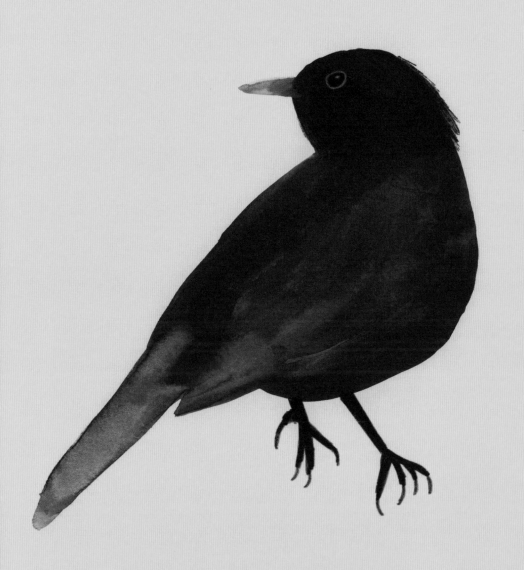

LITTLE OWL
Frankfurt, Germany

22cm (8²/₃in)

56cm (22in)

180g (6¹/₂oz)

As Europe's second smallest owl (only the diminutive pygmy owl is smaller), the little owl is about the size of a starling, though it weighs more than twice as much due to its powerful, stocky build. Despite its small size, the little owl is more easily seen, unlike most other members of its family, being largely diurnal in its habits, hunting mainly around dawn and dusk.

Across most of its European range (including Britain, where the species was introduced during the nineteenth century) the little owl is primarily a bird of farmland areas and open countryside. But in the German city of Frankfurt it has taken to urban – or at least suburban – life. Little owls can frequently be seen perched on the branches of trees, staring intently down with their piercing yellow eyes. When they fly, their wings appear very rounded.

Most of Frankfurt's little owls choose to breed in specially built nest boxes, which are mainly put up around the city's suburbs, in an area known as the Orchard Meadows. This unusual habitat, made up of flower-rich meadows and clusters of trees, was created by traditional fruit growers, and is home not just to the owls but also to other specialised orchard birds such as wrynecks and redstarts, and a suite of scarce butterflies. However, the meadows are now at risk, and measures are being taken to conserve their unique wildlife.

The owls in Frankfurt are highly successful: in 2016, ninety-one breeding pairs raised 160 chicks – almost two per pair – making this one of the highest concentrations of little owls found anywhere. Ironically, in the open countryside outside the city, little owls are in decline, probably because intensive farming – using agricultural chemicals – is killing off the small mammals and insects on which they feed.

Little owls have a long cultural history. Their scientific name, *Athene noctua*, is a reference to the Greek goddess of wisdom, while the call of the little owl is said to have heralded the murder of Julius Caesar. The little owl is also traditionally a symbol of good luck, with Greek armies heading into battle beneath owl banners.

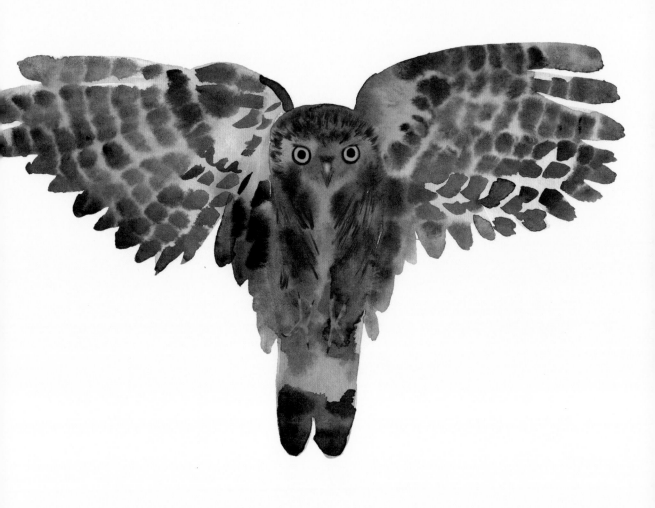

COLLARED DOVE
Hamburg, Germany

Despite being a common sight in Hamburg's parks, including the Planten un Blomen in the heart of the city, the collared dove is known affectionately by Germans as '*die Fernsehtaube*' (the 'television dove'). This is because the species also spends a good deal of time perched on TV aerials on the roofs of suburban houses. Yet this familiar bird, whose monotonous cooing is a regular sound in Hamburg – as in many other German towns and cities – was not even seen in Germany until the final year of the Second World War, 1945.

As peace finally came to Europe, this attractive member of the pigeon family had begun an invasion of its own. Back at the end of the nineteenth century it was found across much of southern Asia, from China, India and Sri Lanka in the east to Turkey in the west, with only a handful of records from Europe. Then, sometime early in the twentieth century, it began to spread westwards. With little or no competition for food, the species thrived in its new home. Collared doves reached the Balkans by 1920, Germany in 1945, Britain in 1953 and Ireland in 1959. Today, they are a familiar sight in cities and suburbs throughout Europe.

Mainly pinkish-brown in colour, with darker wings and a black, beady eye, the collared dove's most distinctive feature is its black collar, which is fringed with white – giving the species its name. The wood pigeon also has a collar, but this is white, and the bird is much larger and bulkier than its diminutive cousin, so is unlikely to cause confusion. Collared doves make a range of sounds, including a rather repetitive three-note cooing, which can be likened to the soft notes of a distant steam train 'choo-chooo-choo'.

In the mid-1970s, a flock of collared doves escaped from captivity in the capital of the Bahamas, Nassau. They soon spread to the United States, where they are now widespread in the southern state of Florida, though much rarer further north. Ironically, given the bird's ubiquity in Germany, birders in Pennsylvania were delighted to spot a vagrant collared dove during their annual Christmas Bird Count in 2009. The town where it was found? Hamburg, PA!

 32cm (12½in)

 51cm (20in)

 200g (7oz)

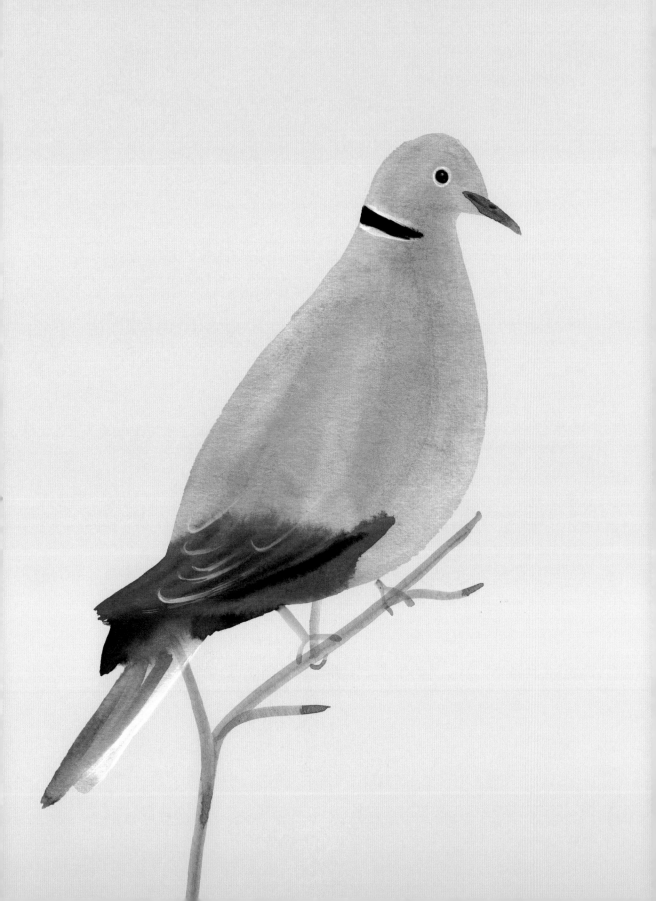

NORTHERN GOSHAWK

Berlin, Germany

54.5cm (21½in)

1m (3¼ft)

1.2kg (2½lb)

When it comes to birds of prey, few are as impressive as the goshawk. This larger cousin of the more familiar sparrowhawk is built to kill, equipped as it is with a bulky body, powerful wings and huge talons, each armed with sharp claws that are ideal for despatching unfortunate victims.

Slaty blue-grey above, and barred black and white below, a goshawk has piercing orange eyes, which it uses to spot its prey – anything from woodpigeons to crows, and even birds as large as pheasants. As with all hawks, the female is considerably larger than the male, being almost as big as a buzzard. Despite their large size, however, these birds are mainly ambush predators, perching unobtrusively until they see an opportunity to hunt.

In much of its European range, the goshawk is a scarce and elusive bird, usually only seen in early spring, when pairs perform courtship displays above the forest canopy. There is one notable exception to this, however. In Germany's capital Berlin, goshawks breed at some of the highest densities in the world, with roughly 100 pairs living within the city's boundaries. Like urban peregrines, Berlin's goshawks prey mainly on pigeons, which they snatch out of the air, but they also take other birds and mammals, including red squirrels.

Goshawks thrive in Berlin because it is one of Europe's most wooded cities, with enough tall trees for the birds to nest away from predators. Another advantage is that they are safe from human persecution. In rural areas goshawks are often illegally killed because they prey on gamebirds.

Berlin's goshawks start breeding in early spring, the female building her nest out of twigs in tall trees in the city's parks and open spaces, including the Tiergarten, Berlin's most famous park. The birds also nest on high buildings. A female lays three or four eggs in mid-April, which she incubates for more than five weeks. The young then fledge and leave the nest another five or six weeks later, in late June or early July.

Normally shy, these Berlin-based raptors are now very tolerant of city people going about their business and have little or no regard for the crowds passing below.

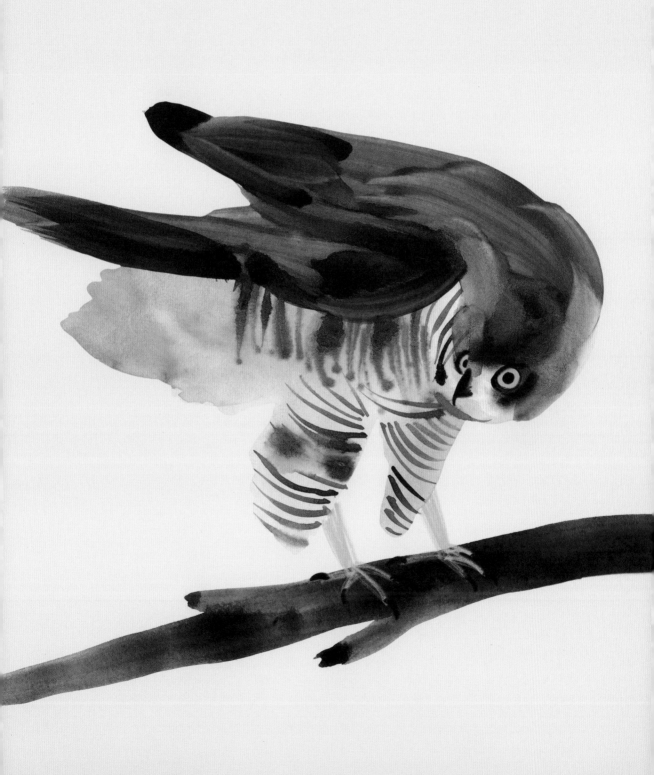

ALPINE SWIFT
Zürich, Switzerland

 21cm (8¼in)

 56cm (22in)

98g (3½oz)

No other group of birds masters the airspace above our cities as well as swifts. Many of the world's hundred or so species hunt above urban areas, where the extra warmth encourages the flying insects on which they feed. Few swifts are as spectacular as one of the largest members of the family: the Alpine swift of central and southern Europe and Asia. This can easily be told apart from its relatives by its huge size – a wingspan of 56cm (22in) on average – and white belly and throat.

Given their name, it is appropriate that Alpine swifts are commonly seen over the Swiss city of Zürich, a short distance from Europe's highest mountain range. Like other swifts, the Alpine originally evolved to nest on mountain crags and cliff faces, but in the past century or so has adapted to breed on tall buildings, a habit recorded by the Victorian naturalist William Chapman Hewitson, who travelled to Switzerland from Britain to collect the bird's eggs.

In Zürich, Alpine swifts nest beneath the eaves of a large department store, above street cafés. They often fly very high, but in cool, unsettled weather they hunt for insects just above the ground, often skimming along the River Limmat or over the surface of nearby Lake Zürich. They have also been seen hunting at night, using street lights, which attract insects such as large moths.

Recently, Swiss scientists placed data loggers on six Alpine swifts, to follow their migratory route south. They discovered that the birds spend up to 200 days a year on the wing, including the whole of their time in Africa. However, they are outdone by common swifts, which can spend several years in flight without landing.

Alpine swifts fly high into the sky each evening, their bodies being specially adapted to retain haemoglobin in their blood, so that they can spend prolonged periods at high altitudes. In bad weather they will also roost communally on the sides of buildings.

In several Swiss cities, Alpine swifts now breed in specially designed nest boxes, often rigged with webcams so that their progress can be watched live, online.

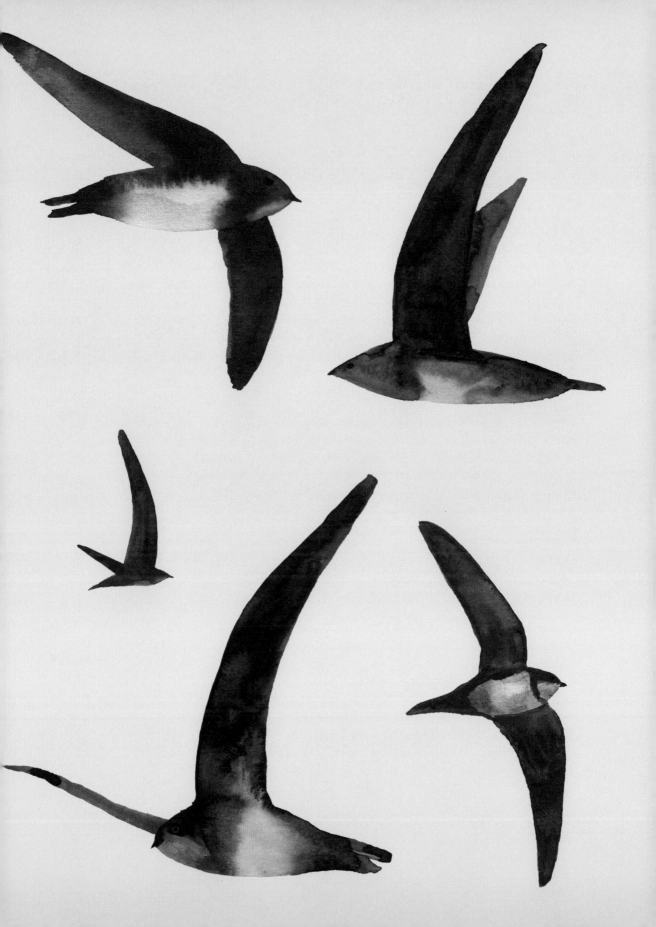

BARN SWALLOW
Vienna, Austria

18cm (7in)

30cm (11¾in)

21g (¾oz)

Of the many species of bird that visit Europe from Africa each year, the barn swallow is proverbially considered the classic sign of spring. So, it's perhaps surprising that this familiar species has been chosen as the national bird of only two countries: Estonia and Austria.

Although swallows are more usually associated with rural habitats – nesting, as their name suggests, on the beams of barns and other farm buildings – they also have a deep cultural connection with Austria's capital city, Vienna. The late-nineteenth century Bohemian composer Ludwig Schlögel named one of his best-known pieces the 'Wiener Schwalben Marsch' – which translates as the 'Vienna Swallow March'.

Swallows return to Vienna in late March and early April. The males usually arrive back first, establishing their territory by flying around and uttering loud, twittering calls. Once the females come back, about a week later, each eyes up the males and tends to choose the one with the longest, and most symmetrical tail streamers as her mate: this presumably suggests that the males are healthy and will pass on their strong genetic heritage to their offspring.

The birds often gather along the banks of Vienna's rivers: the Wien, which flows right through the centre of the city, and the Danube, which skirts around the outskirts. As well as hunting small flying insects, which they snatch on the wing with their broad bills, the birds may also descend to the banks to pick up mud with which they build their nests.

In recent years, swallows have begun arriving back to many parts of Europe earlier and earlier each spring, in response to global climate change. In Britain, for example, they now return up to two weeks earlier than the long-term average. However, scientists at the University of Vienna have analysed the return dates for swallows in eastern Austria – including around Vienna itself. From 1951–1999, in contrast to many other European countries, the arrival dates for returning swallows (as well as cuckoos) have been later than average. This may be the result of dryer conditions in the birds' winter quarters in sub-Saharan Africa, leading to later departure dates for the birds.

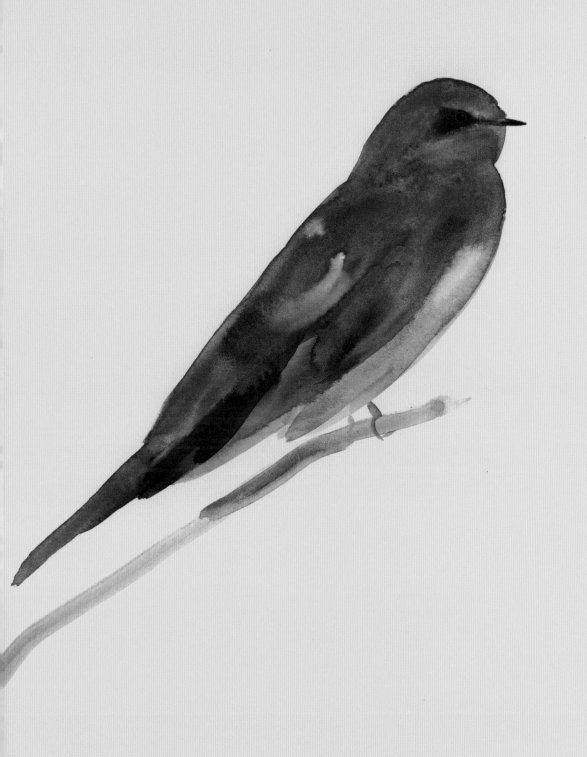

BLACK-NECKED GREBE

Venice, Italy

31cm (12¼in)

58cm (22¾in)

360g (12¾oz)

Twenty million tourists visit the unique city of Venice every year. That's 60,000 people a day – more than the entire resident population of 55,000 citizens. You might imagine there wouldn't be much room for wildlife, yet the Venice lagoon attracts almost 300,000 waterbirds every winter. It's one of Europe's key wetland sites, and the largest in the whole of Italy. The good news is that numbers are on the up, rising fourfold in the past two decades.

Amongst so many waterbirds, large and small, it is easy to miss the black-necked grebe. Almost 2,000 of this diminutive bird regularly spend the winter here, nearly two per cent of the entire European population. In some winters grebe numbers can reach over 3,500.

The black-necked grebe is the second smallest of Europe's five grebe species (slightly larger than the little grebe), and as a result of its small size it mainly feeds on tiny fish and aquatic invertebrates. In spring and summer, it shows the black neck that earned the bird its name, together with a dashing plume of yellow feathers behind each eye. In winter the bird sheds its splendid breeding plumage in favour of a more utilitarian black, white and grey garb – though it does have bright-red eyes.

While the largest flocks of black-necked grebes are found on Venice's larger lagoon, the birds also regularly venture into the city's labyrinthine canal system, alongside their larger cousins, great crested grebes. Here they dodge the many gondolas ferrying tourists through the city, diving beneath the surface of the water to catch their food. One of the best places to watch them is the San Marco promenade in the south of the city, though birders have also reported seeing 'thousands of grebes' from the ferry to and from the city's airport.

Other waterbirds found in and around the city include thousands of ducks – mainly teal and mallard; waders such as dunlins, vast flocks of coots and more than 4,000 greater flamingos. During migration periods, huge flocks of black terns and Mediterranean gulls pass through. We know this, because teams of ornithologists survey the lagoons regularly using boats and aircraft.

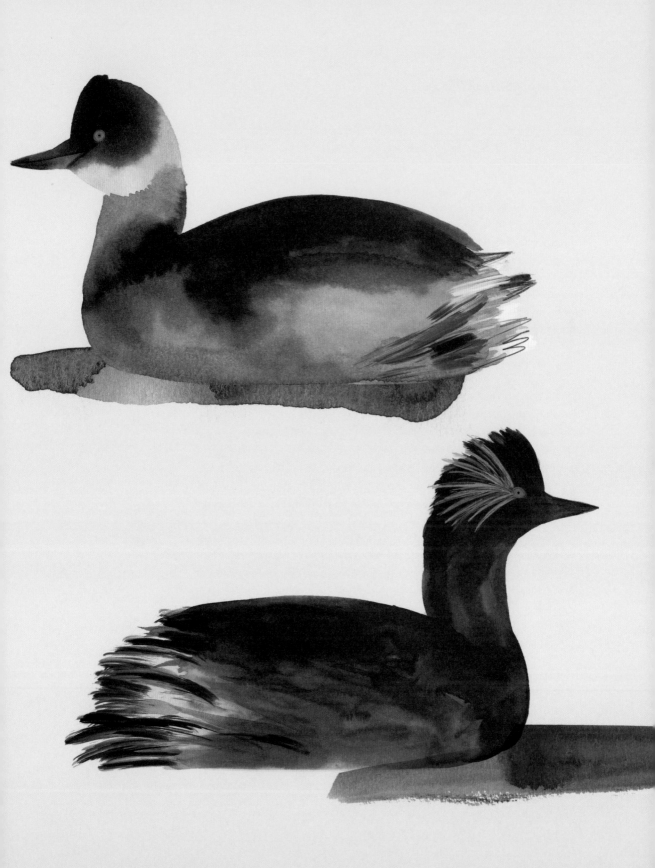

ITALIAN SPARROW

Florence, Italy

16cm (6¼in)

21.5cm (8½in)

30g (1oz)

Italian cities are not generally known for their birds, but the cradle of the Renaissance, Florence, is home to one of Italy's most special species. It also happens to be one of the most overlooked.

On the terrace café of the famous Uffizi Gallery, home to Botticelli's *Birth of Venus* and *Primavera*, few visitors pay any attention to the sparrows. Yet these are not the usual house sparrows, found in cities elsewhere in Europe, but an entirely separate species: the Italian sparrow.

To be fair, you have to look quite hard to spot the difference. The females of the two species are almost identical, being a rather drab greyish-brown, while the main difference in the males is that, instead of having a grey crown, the Italian sparrow has a rich chestnut shade.

For many years, the Italian sparrow was considered to be a well-marked race of the house sparrow. In 2011, however, DNA tests proved that it was indeed a species in its own right. There is much debate as to its origins, but the latest theory is that it evolved from a stable hybrid between the house sparrow and the Spanish sparrow, a species found not just in Spain, but also across North Africa, southeast Europe and the Middle East.

As well as being common in most of the country's cities, Italian sparrows are also found from the Alps in the north – where they often interbreed with house sparrows – south to Sicily, and on the French Mediterranean island of Corsica.

Like other members of its family, the Italian sparrow is a very sedentary species that lives alongside human beings in villages, towns and cities. Until the 1990s, it was one of the few Italian songbirds on the increase, probably because of a rise in urbanisation. However, in the first five years of the new millennium its numbers fell by more than one-quarter, while in cities the drop has been even greater, probably due to a shortage of insect food.

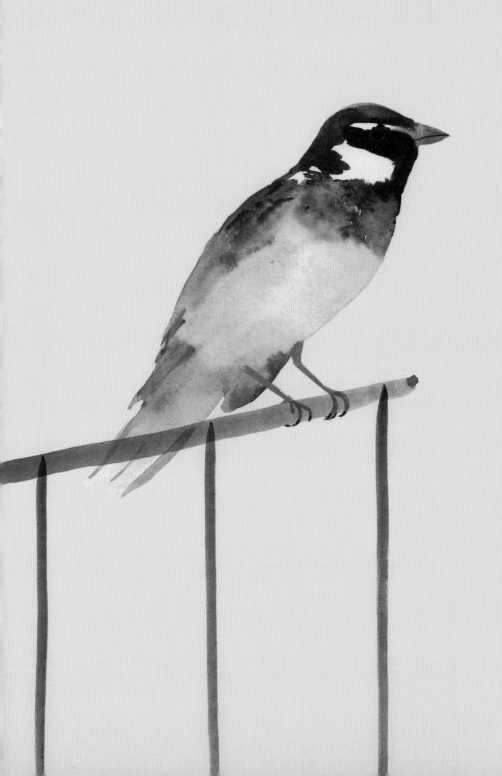

COMMON STARLING

Rome, Italy

21.5cm (8½in)

35.5cm (14in)

80g (2¾oz)

In winter, dusk falls early over the Eternal City of Rome, as the city's busy commuters head home for the night after work. Most do not even bother to look up towards the rapidly darkening skies – until, that is, they hear what sounds like a great whoosh of air, right over their heads. The sound is made by the wings of a huge flock of starlings: up to five million of them.

The collective term for starlings is a 'murmuration' – but whether this comes from the whispering of their wings beating in unison, or refers to the chattering sounds they make once they have finally landed, is not known.

What we do know is that, throughout Europe, starlings habitually gather in vast flocks to roost for the night during the winter months. Usually these roosts are in rural areas, but flocks of starlings will also come into towns and cities on a winter's evening, and perch on the ledges of buildings.

It makes sense to roost in a city, as the birds benefit from the urban heat-island effect (see page 6). City lights may also help deter some predators, such as hawks and owls. Starlings gather in these huge numbers for safety and warmth, but also to exchange information about the best places to feed the next day, in the countryside surrounding Rome.

While the Rome starling roost has become something of a tourist attraction in recent years, it is not quite so popular amongst the locals, who resent having to cope with a rain of the birds' droppings, especially when these fall on their precious cars. The city authorities have done their best to discourage the birds, using a combination of trained hawks and loud noises, but this doesn't seem to have worked. So, instead, perhaps they should simply sit back and enjoy the amazing aerial acrobatics of these birds as they swirl around the city's historic monuments, before finally settling down to roost for the night.

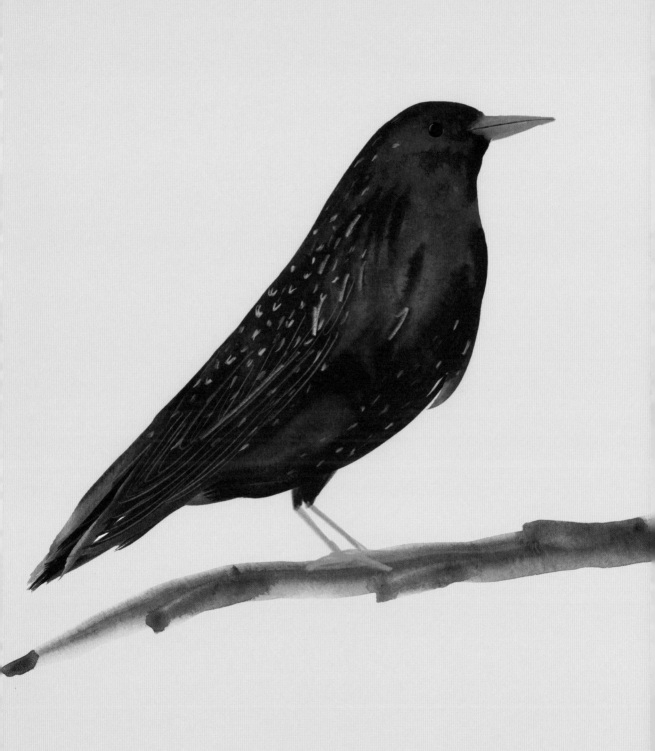

EUROPEAN HONEY-BUZZARD

Messina, Italy

56cm (22in)

1.3m (4¼ft)

705g (1½lb)

Of all Europe's birds of prey, the honey-buzzard is one of the most unusual. Superficially like the common buzzard, with broad, fingered wings, a long tail, and a slightly smaller, pigeon-like head, it feeds almost exclusively on the grubs of bees and wasps. It was this habit of raiding their nests to get its food that led to its rather misleading name – the Dutch 'wespendief', meaning 'wasp thief', is more accurate.

The honey-buzzard is a summer visitor to Europe, migrating to and from its wintering grounds in equatorial Africa each spring and autumn. Like other raptors, it has difficulty crossing large areas of water, so European birds head to Africa via three places with shorter sea crossings than elsewhere: Gibraltar, the Bosphorus in Turkey, and the southern Italian island of Sicily. Here, one of the best places to watch honey-buzzards in large numbers is the city directly opposite Italy's toe: Messina.

Its strategic position makes Messina a very significant migration site for raptors: it's the most important site in Europe for kestrels, hobbies and marsh harriers. It also provides sightings of scarcer species such as Eleonora's falcons, pallid and Montagu's harriers and long-legged buzzards.

Messina is best known for the honey-buzzard migration, which occurs from the third week of April, peaking in the first two weeks of May, and continues into early June. Up to 27,000 honey-buzzards come by during this time, and on good days there may be several thousand birds passing through.

Until recently, any honey-buzzard making the crossing over the Straits of Messina risked being shot – as many as 5,000 a year fell to the guns. Recently, however, Italy's bird conservation organisations have teamed up with local people to run 'raptor camps' aimed at discouraging the shooters and drawing attention to the birds' plight.

The movement to protect Messina's honey-buzzards was originally started by a fifteen-year-old girl, Anna Giordana, who in 1981 witnessed the illegal killing of the birds. Despite many threats, she persisted, and thanks to her vision – and the work of hundreds of volunteers – the death rate for honey-buzzards and other raptors has fallen dramatically.

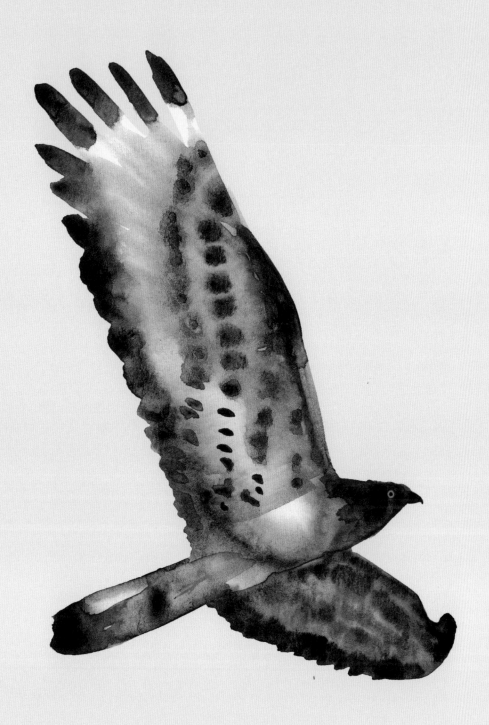

WHITE STORK
Warsaw, Poland

'Every fifth white stork in Europe is a Pole' is a proud and accurate boast. Although these majestic waterbirds nest in villages, towns and cities throughout much of southern and eastern Europe, the Polish population of roughly 50,000 breeding pairs makes it one of the most familiar species in the country.

1m (3¼ft)

1.6m (5¼ft)

3.3kg (7¼lb)

That includes the country's capital, Warsaw, where the city's art gallery has a famous picture of storks flying overhead. In another Polish city, Wrocław, storks nest on the synagogue, the only one in the country that wasn't destroyed during the Second World War. Each day they fly out of the city centres to feed in nearby fields, mainly eating insects, along with fish and frogs.

White storks spend the winter in Africa, south of the Sahara desert, and return in early spring, flying up to 10,000km (6,200 miles) in large flocks and arriving back in Poland around the end of March.

They are welcomed as a key sign that the long, cold winter is now over and spring is on the way; though there may still be snow lying on the ground when they arrive. They soon pair up, and start rebuilding or repairing their nests: huge piles of sticks weighing up to two tonnes on the tops of buildings. Many Poles build special frames on the roofs of their homes or public buildings to encourage the storks. That's because having a pair nesting on your roof is seen as a sign of good fortune – even a protection against the house catching fire or being struck by lightning.

Storks are, across their entire range, associated with fertility and are often depicted carrying a baby (even in countries such as Britain, where they are only a rare visitor). This is thought to have arisen partly because of their link with the season of spring, and also because – with their vertical stance – they are regarded as phallic symbols.

White storks are popular all over eastern Europe, where they are the national bird of Belarus and Lithuania. But the Poles really celebrate this species, designating 31 May as 'White Stork Day' across the whole country.

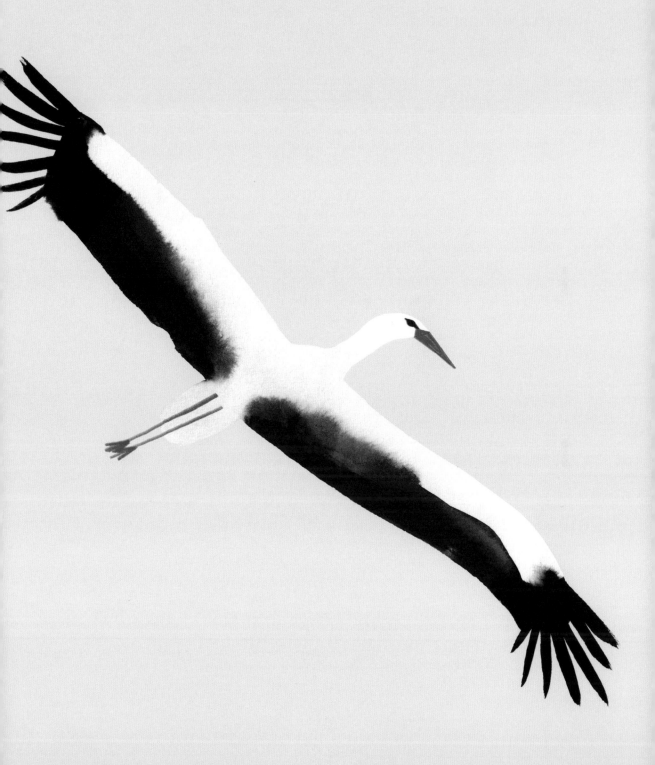

SYRIAN WOODPECKER
Budapest, Hungary

23cm (9in)

37cm (14½in)

75g (2¾oz)

The Hungarian capital of Budapest is one of the most wooded of all European cities, making it an ideal home for woodpeckers. It has a total of seven species in all, four more than are found in the whole of the British Isles. Six of these species – the great, lesser and middle spotted, the black, green and grey-headed – have long been found here. But the seventh, the Syrian woodpecker, is a relative newcomer.

As its name suggests, the Syrian woodpecker's original range was the Middle East. During the course of the twentieth century it gradually spread northwards and westwards, colonising southeastern, and then eastern, Europe. Today, it is a common and familiar bird throughout this region, as far west as Austria, Poland and the Czech Republic.

One of the reasons for this is that, unlike many of its relatives, the Syrian woodpecker is well adapted to living in cities. It is especially suited to life in urban oases, such as parks, gardens, cemeteries and other green areas. That's because, unlike most other woodpeckers, it favours open areas over dense forest.

Syrian woodpeckers feed on fruit, making orchards and gardens suitable habitats. They have also taken advantage of the fact that, in cities, air pollution often makes trees weaker than in rural areas, so that the woodpeckers are able to make a nesting hole more easily.

Interestingly, having arrived, the Syrian woodpecker has begun to hybridise with its cousin the great spotted woodpecker, with as many as one in twenty pairings being mixed.

The two species are, at first sight, very similar: each is a medium-sized, black-and-white woodpecker with red on the back of the head. The main difference is that the Syrian woodpecker has a paler, almost pink, patch of red under its tail, and a larger white face patch, with the black band not going all the way to the back of its neck.

Whether the Syrian woodpecker will continue to expand its range through western Europe is, perhaps, unlikely: in recent years it seems to have slowed down, though climate change may lend it a helping hand in the future.

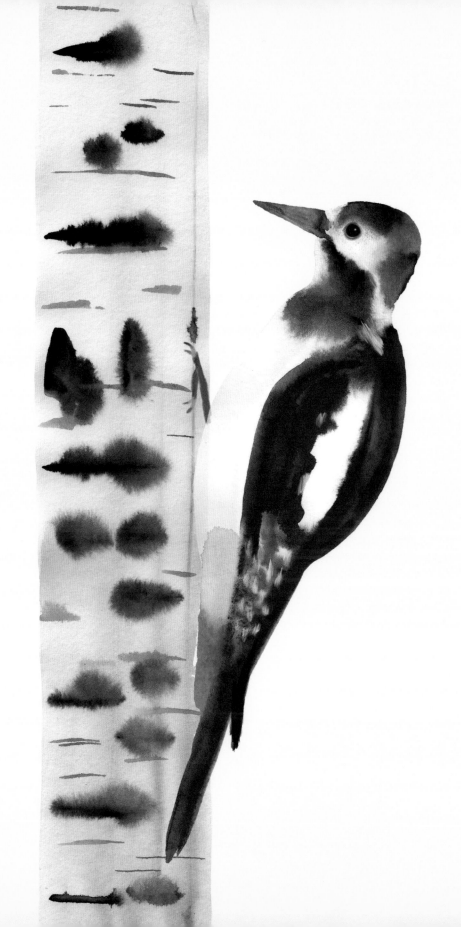

LONG-EARED OWL
Kikinda, Serbia

Of all Europe's owls, the long-eared is one of the most mysterious and hardest to see, because of its secretive and mainly nocturnal habits. But there are exceptions to every rule, and with long-eared owls, the key is to find a winter roost.

37.5cm (14¾in)

95cm (37½in)

305g (10¾oz)

These often occur in towns and cities, as the owls take advantage of the urban heat-island effect that makes these areas warmer than the surrounding countryside. It gives the birds a better chance of surviving the cold winter nights. The most spectacular of all roosts occurs in the northern Serbian city of Kikinda, close to the country's border with Romania.

At least 700 individual owls roost here during the winter months, with as many as 145 in the same tree. This is thought to be the largest gathering of long-eared owls found anywhere in the world, and has helped create a minor tourist boom for the city, as thousands of birders flock here from November to March to witness this spectacular gathering. The city residents are not averse to teasing the visitors for adopting what is called 'the Kikinda stance': standing under the trees with their heads back, staring open-mouthed at the spectacle above their heads. As a result of this interest, Kikinda was recently named one of the ten most important urban environments for birds anywhere in the world.

The owls have been warmly welcomed by local residents, partly because of the tourist revenue they bring, but also because the owls are highly effective pest controllers. As dusk falls each evening, they head off into the arable fields surrounding the city to feed, preying on rats, mice and other small mammals – an estimated half a million every year. Indeed, the large number of rodents – a result of traditional farming methods – is what attracts the owls in the first place.

The locals say that owls have always spent the winter here, though it is only recently that they began to attract tourists. Now the shops sell plenty of owl souvenirs, while the city's children dress up as owls in the month of November, a fine example of how birds are accepted into local culture.

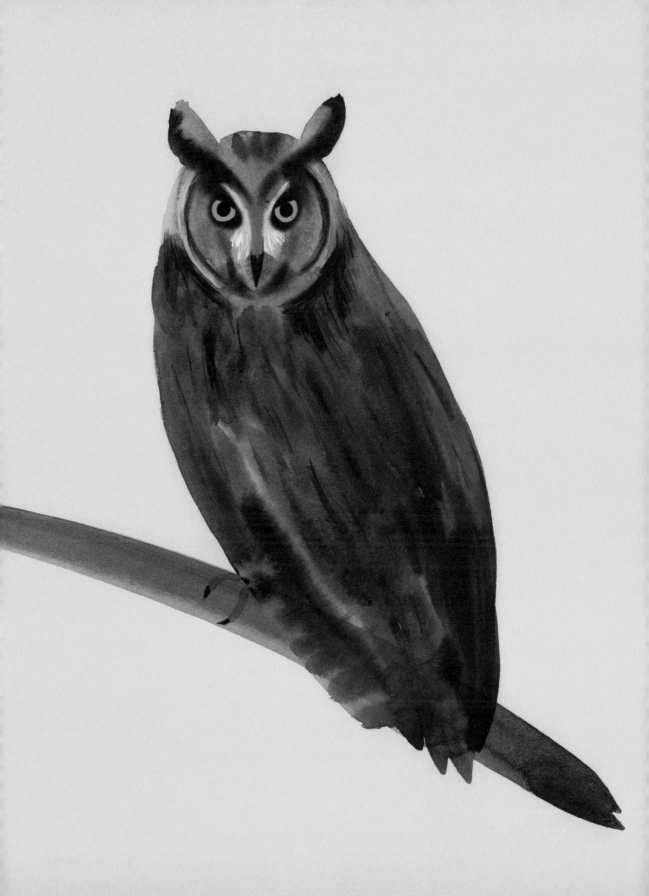

CORNCRAKE

Moscow, Russia

28.5cm (11¼in)

47.5cm (18¾in)

170g (6oz)

If there were a prize for the most secretive bird, the corncrake would certainly be a prime contender. Although these birds are found across much of Europe and Asia (as far east as China), and migrate to and from Africa for the winter, they are hardly ever seen, hiding themselves away in long grass or cereal crops.

The only evidence they are there at all comes from their repetitive, far-carrying and utterly unmistakable call, a twin note that gives the species its scientific name *Crex crex*. If you are lucky enough to catch a glimpse of one, the bird looks rather like a pale-brown moorhen (a distant cousin), with black, brown, buff and chestnut plumage and a long neck.

Corncrakes can be found during the spring and summer in some of Moscow's parks, such as the open, grassy parts of the Losiny Island National Park in the northeast of the city, close to the main Leningradsky railway station. One area, which is home to fifteen million people, has more calling corncrakes than the whole of western Europe.

Corncrakes originally evolved in wild grasslands, but with the development of agriculture from the eighteenth century onwards, became one of our most typical farmland birds. As farming became more and more efficient, especially in western Europe, the species began a long, slow decline. In Britain, for example, it was once found throughout the lowland countryside. Today, however, it is confined to the far north and west of Scotland, where traditional farming methods still prevail.

In eastern Europe and Russia, where the vast majority of the world's corncrakes are found, a history of less intensive agriculture means that these birds are still fairly common and widespread. Under communism, with its huge collective farms, the species began to decline, but after the fall of the Soviet Union in the late 1980s, many loss-making properties were simply abandoned, and pesticide use fell sharply. As a result, corncrake numbers in Russia slowly began to rise again. Now, though, agriculture is once again becoming more intensive, so the species may soon be in trouble again.

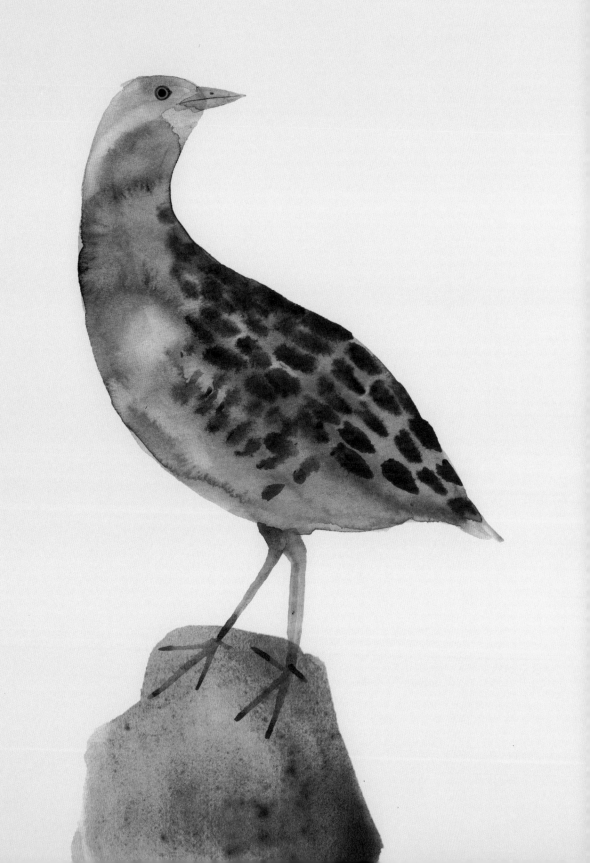

PIED KINGFISHER
Cairo, Egypt

The ancient Egyptians worshipped many creatures, especially birds. Their tombs were decorated with several species still found in the region today, including hoopoes, swallows and one of the most familiar of Egypt's birds: the pied kingfisher.

28cm (11in)

46cm (18in)

90g (3oz)

Passengers of pleasure boats voyaging up and down the River Nile marvel at this bird's aerobatic skills, and the birds are common in the country's capital, Cairo, which the river bisects.

Known as 'Abu Ghuttaas', which roughly translates as 'father of those that dunk', this black-and-white waterbird's local name derives from its extraordinary ability to hover in one position above the water, before plunging down to grab a fish from beneath the surface.

The pied kingfisher has the distinction of being the largest species of bird that can hover under its own wing power – kestrels and buzzards are larger, but they use the wind to keep themselves in position. Kingfishers have another clever trick: unlike other members of their family, they are able to despatch and eat their prey on the wing, saving them the time and trouble of returning to their perch. This also enables them to hunt over large areas of open water.

Both ancient and modern Egyptian civilisations have depended on the Nile; in a country that is mostly hot, dry desert, the river brings life. By using the river's waters to irrigate the vast Nile Delta, digging irrigation channels that are well stocked with plentiful supplies of fish, generations of Egyptians have enabled the kingfishers to flourish. The birds have been helped by the proliferation of telegraph wires across the city and its surroundings, on which they can perch and survey the waters below, before heading off to hunt.

There are close to 100 species of kingfisher in the world, on six of the seven continents, and several species – including the familiar common kingfisher – have adapted to living in urban areas. Yet the pied kingfisher is the monarch of the waterways, being found in built-up areas throughout the Middle East, sub-Saharan Africa, India and Southeast Asia.

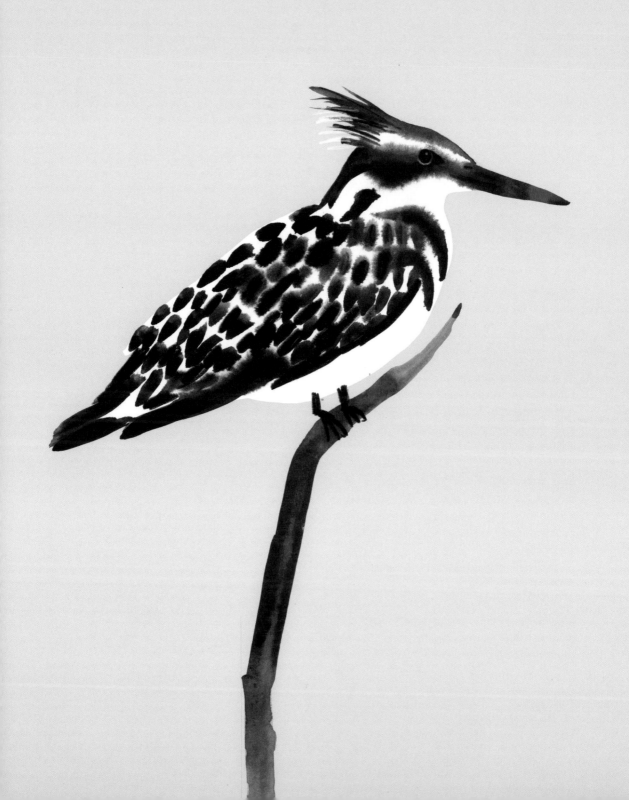

WATTLED IBIS

Addis Ababa, Ethiopia

70cm (27½in)

1.2m (4ft)

1.2kg (2½lb)

Birders visiting Ethiopia mainly come to see the region's thirty or so endemic species: birds found here, and in neighbouring countries in the Horn of Africa, but nowhere else in the world. For many, this requires long treks into the bush, in search of the rare and elusive Prince Ruspoli's turaco and Stresemann's bush-crow.

One Ethiopian endemic – the wattled ibis – is so common and widespread, however, that it can be seen in parks and flying overhead in the country's capital city, Addis Ababa.

In many ways typical of the world's two dozen or so ibis species, the wattled ibis has long legs, suitable for wading in water, and a long, downcurved bill, which it uses to catch aquatic creatures. The main difference between this and other ibises is the wattle – a long flap of skin that hangs down below its throat. In flight, wattled ibises can be distinguished from the two other mainly dark-coloured species of ibis that occur here (glossy and hadada) by the large white patches on their upper wings.

These birds are very relaxed amongst people, and happily forage for food such as insects and other invertebrates on grassy areas around the city, including the gardens of hotels. They also hang around ancient monuments such as the Old Palace, the National Palace and Trinity Cathedral in the city centre.

The reason for the wattled ibis's restricted range is that it mostly lives in areas more than 1,500m (4,900ft) above sea level, to as high as 4,100m (13,450ft) – hence it is confined to high-altitude areas of Ethiopia and its neighbour Eritrea. Although they have a very restricted world range, they are abundant where they do occur, and so are not considered threatened.

Wattled ibises breed in colonies, building their nests out of branches and sticks on cliff ledges to avoid predators. They also roost together in large flocks, and are especially noisy when they leave the roost at dawn; they make a rather goose-like cacophony of calls, which mingle with the sounds of city traffic. In parts of Ethiopia, the name of the bird is also given to a very talkative person.

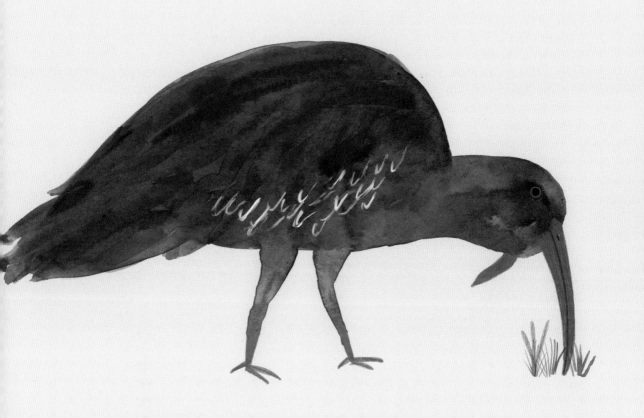

BLACK-AND-WHITE CASQUED HORNBILL
Kampala, Uganda

65cm (25½in)

1.1m (3½ft)

1.15kg (2½lb)

Like Rome, Kampala is built on seven hills, but that is where the similarities between the two cities end. Uganda's capital city is now home to more than 1.5 million people, and covers an area of almost 200 square km (78 square miles). During its expansion, this sprawling metropolis has spread over much, once natural habitat to reach the shores of Lake Victoria, Africa's largest inland body of water.

Yet the wildlife still manages to cling on, with more than 300 different species of bird found within the city boundaries. These include unexpected species such as the forest-dwelling black-and-white casqued hornbill, which nests in the few large, mature trees still left standing here.

One of the biggest members of its large and varied family, the black-and-white casqued hornbill is, as its name suggests, black on the head, back and belly, with black-and-white wings and a barred tail. The 'casque' refers to a large, horny protuberance on the upper mandible of the bird's beak, the feature that gives hornbills their name. This hollow structure may be used to enhance the bird's sound in standoffs between rival males. Male hornbills weigh 1.3kg (2¾lb) on average, while females are slightly smaller, with a less prominent casque.

Like other hornbills, this species is omnivorous, feeding on fruit (at least forty different kinds), as well as hunting lizards, frogs, bats, and the eggs and chicks of smaller birds.

The birds nest in a hole or cavity in a tree or amongst rocks and, as with other members of the family, the male seals the female inside the nest with mud, to keep her safe from predators. This does, however, mean that he then has to bring back all the food for her and the growing chicks inside, which he does by regurgitating fruit from his bill into hers.

Black-and-white casqued hornbills usually have two chicks, but rarely raise more than one, as the weaker, smaller chick generally dies of starvation. Like other hornbills, the bird has a loud, musical call which is often given in unison with others, creating an incredible din, very familiar to all Kampala's inhabitants.

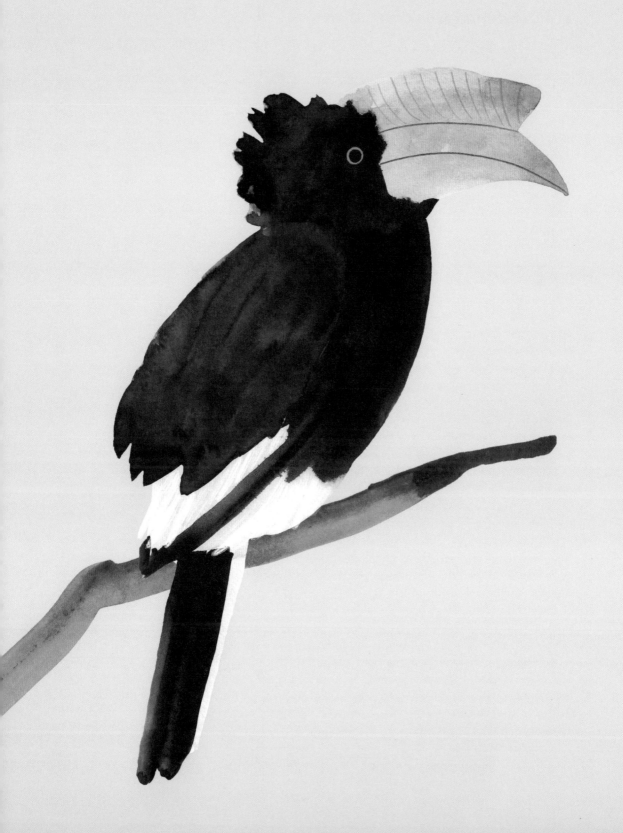

AFRICAN PENGUIN
Cape Town, South Africa

65cm (25½in)

n/a

2.9kg (6½lb)

If there is one continent on which you wouldn't expect to see a penguin, it must surely be Africa. Yet, along the coasts around Cape Town, near the southern tip of South Africa, there are large, noisy colonies of the charismatic African penguin.

Also known, somewhat unflatteringly, as the Jackass penguin (after its loud, braying call), the African penguin is – like all other members of its family – completely flightless. On land, these birds appear rather comical, as they waddle around like smartly dressed elderly gentlemen. But once they dive beneath the surface of the ocean, they transform into graceful, fast and highly effective hunters.

Until the early 1980s, most African penguin colonies were on offshore islands outside of Cape Town's city limits. Then, in 1983, four pioneering birds from a nearby colony moved onto Boulder Beach, Simonstown, which is within the city itself.

At first, the penguins were seen as a nuisance, as they caused damage by invading people's gardens, but soon it became clear that they could attract locals and tourists, who flocked to see the birds. Today, up to 60,000 visitors a year bring much-needed cash into the local economy – an estimated two million US dollars annually.

The penguins would never normally choose to breed on the mainland, because that would leave them vulnerable to land-based predators; yet because there are so many people living around them, they are safe.

Overall, though, numbers of Africa's only penguin are plummeting. Just over a century ago the population was estimated at roughly 1.5 million birds, and as recently as the mid-1990s there were still thought to be 200,000 individuals. Yet today, just over 50,000 remain.

Even the Boulder Beach colony, which had grown to over 2,000 pairs, is now down to just 400. Scientists believe the widespread decline is down to climate change, which appears to be pushing their favourite food of fish out into the open ocean, where the penguins cannot easily reach. Overfishing close inshore is also an issue. The situation was not helped when, in 2000, a disastrous oil spill near Robben Island (where Nelson Mandela was held prisoner) killed many penguins.

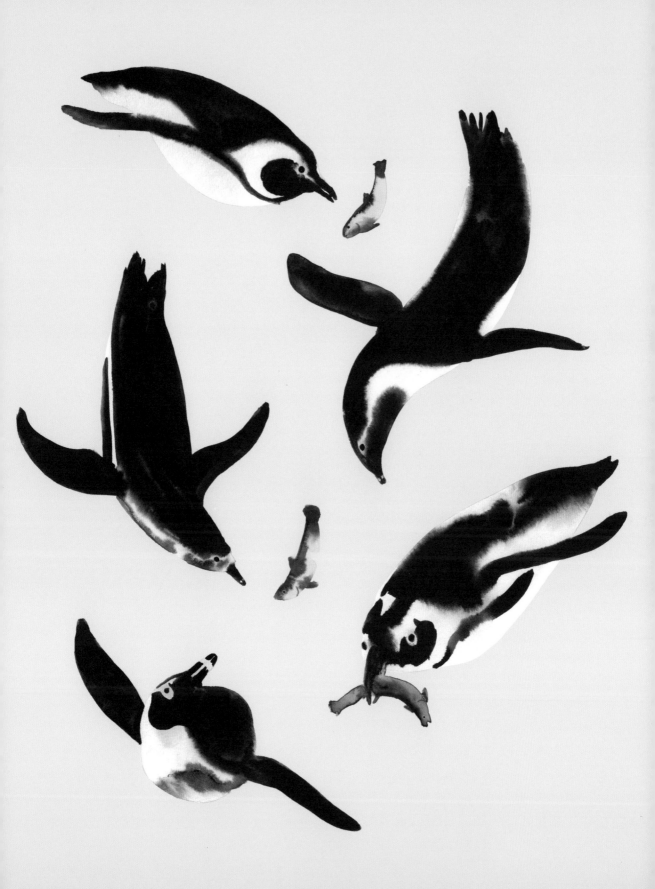

COMMON SWIFT
Jerusalem, Israel

The Middle East is a major global thoroughfare for migratory birds. Hundreds of millions pass through on their way south to Africa in autumn, and then back to their breeding grounds in Europe and Asia in spring. But some birds that spend the winter south of the Sahara desert don't go quite as far – having arrived, they stay put to breed.

17cm (6¾in)

45cm (17¾in)

42g (1½oz)

Each year, during the last week of April, the city of Jerusalem marks the swifts' return with a festival of celebration. The swifts have usually been back since mid-March, and by the time the festival begins may already have young in the nest.

The key site for swifts here is the Western Wall, home to the oldest known colony in the world, dating back at least 2,000 years. This site is sacred to followers of both Judaism and Islam, and so attracts many visitors. Yet the swifts seem unconcerned about their human neighbours, seeing the wall solely as a physical structure where they can nest and raise a family, in the cracks between the stones.

By day, swifts mostly hawk for tiny aerial insects, high in the skies above the city. But each evening, they gather in large, noisy groups, tearing around the wall and nearby buildings like racing drivers, uttering high-pitched screams as they go.

Astonishingly, as darkness falls, they do not go to roost – swifts only land to nest, and spend the rest of their lives in the air. So, at night, they fly to heights of over 3,000m (10,000ft), snatching sleep while airborne.

Before the arrival of human civilisation, swifts would have nested in cracks and crevices in caves, and would probably have been far less common than today. They are one of the few bird species that has benefited from living alongside us.

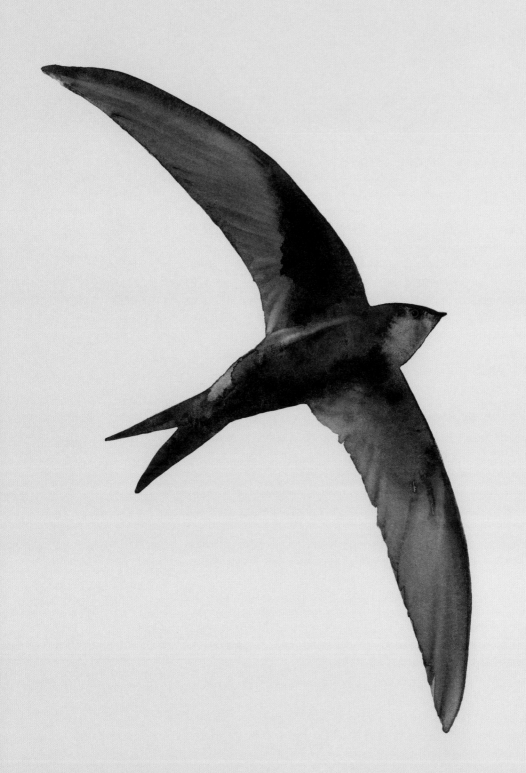

GREY HYPOCOLIUS
Manama, Bahrain

Some birds have a strange hold on keen birders, for whom sighting a rare and elusive species can make a long-distance trip worthwhile. Those that are the sole members of their family have an added allure. One such, found in parts of the Middle East and the Indian subcontinent, is the grey hypocolius.

Despite its large range, this is not an easy bird to see: many countries in which it breeds, such as Iran, Iraq and Afghanistan, are inaccessible or dangerous to foreign visitors. In winter, however, the bird can be found in Bahrain's capital city Manama, and its neighbouring conurbation of Saar, where the world's largest roost – containing several thousand birds – can be seen from October through to April. In recent years, the virtual guarantee of being able to see this species in Manama has led to a boom in ecotourism.

This shy and retiring songbird gets its unusual name from Latin words for 'somewhat like' and 'mousebird'. Hypocoliuses do look superficially like members of this African family, and were put next to mousebirds in the taxonomic order by the nineteenth-century ornithologist Charles Bonaparte – nephew of the French emperor Napoleon.

Since then, scientists have placed the hypocolius in the waxwing, bulbul and starling families, while others have suggested that it may be related to the shrikes. Today, this species stands proudly on its own, in the family Hypocoliidae.

The grey hypocolius is a handsome bird: slender, with an upright posture and pale-grey plumage, contrasting with a black eye mask and black on the wings and tail. When excited it will raise its crest.

Despite its distinctive appearance, the species was not discovered in Bahrain until 1980. Today, they are common throughout the capital, helped by the boom in new parks and gardens, which provide the food the bird needs – primarily fruit, along with some insects and other invertebrates. The birds are especially partial to groves of date palms. Gardens, parks and plantations also provide much-needed drinking water in this arid landscape.

Hypocoliuses gather before they roost in acacia scrub, where they often bathe in dust to remove any parasites from their feathers, before heading off for the night.

23cm (9in)

29cm (11½in)

55g (2oz)

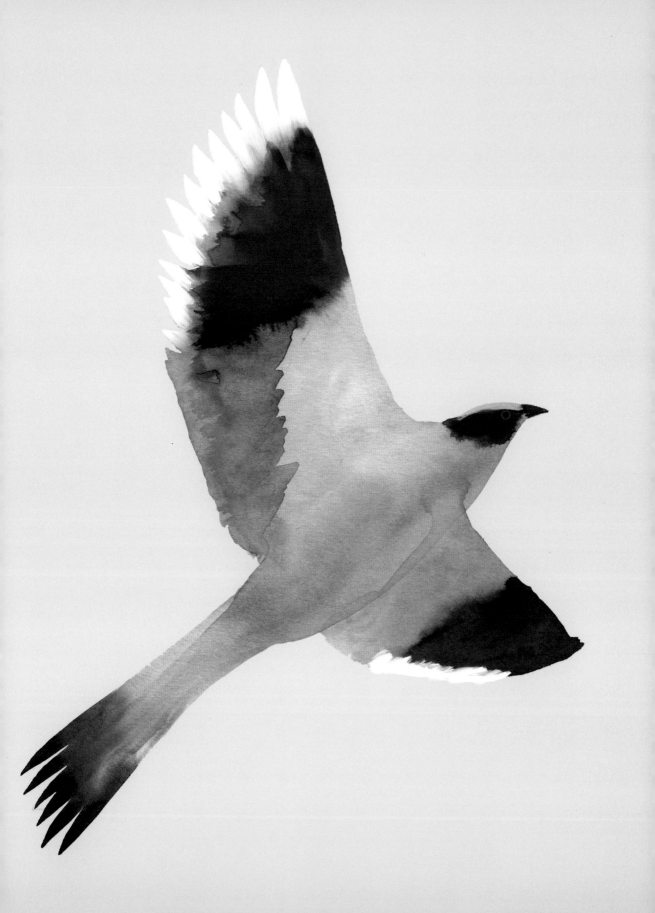

BLACK KITE
New Delhi, India

India's capital city, New Delhi, is home to a wide range of birds, but none are more obvious than the black kite – arguably the world's most successful bird of prey. At times the city skies are filled with these long-winged raptors, with their distinctive narrow-winged and long-tailed appearance.

Because Delhi is such a fast-growing city – the human population now numbers more than twenty-four million people – the urban infrastructure is struggling to keep pace. With one of the highest densities of human beings on the planet – more than 11,000 people per square km (0.4 square miles) – the city has plenty of rubbish dumps, providing rich pickings for these scavenging birds. Sadly, they often live cheek-by-jowl with the people who glean a meagre living from foraging on the same dumps.

Kites also hang around markets, where they snatch pieces of meat or fish from unwary traders or shoppers. In the absence of vultures, whose numbers have plummeted in recent years due to accidental poisoning, kites will also feed on dead cattle (India's sacred animal), which are often left in the streets. Although scavenged food makes up almost two-thirds of this bird's diet, it will also kill prey, especially other urban birds, such as pigeons.

Delhi's black kites form the largest concentration of resident urban raptors anywhere in the world, with an average density of fifteen nests per square km (0.4 square miles). This is far higher than their typical breeding density in the countryside.

Even though kites regularly snatch food, Delhi's people seem to be very tolerant of them: studies have shown that the birds are rarely persecuted, perhaps because the dominant religion of Hinduism preaches tolerance of other creatures. The kites pay back the favour by helping the human residents: they drive out aggressive rhesus monkeys, so helping to reduce the spread of diseases such as tuberculosis and anthrax.

The black kite is a striking example of a species' ability not just to survive alongside vast numbers of human beings, but to thrive – simply by taking full advantage of our wasteful habits.

55cm (21½in)

1.35m (4½ft)

905g (2lb)

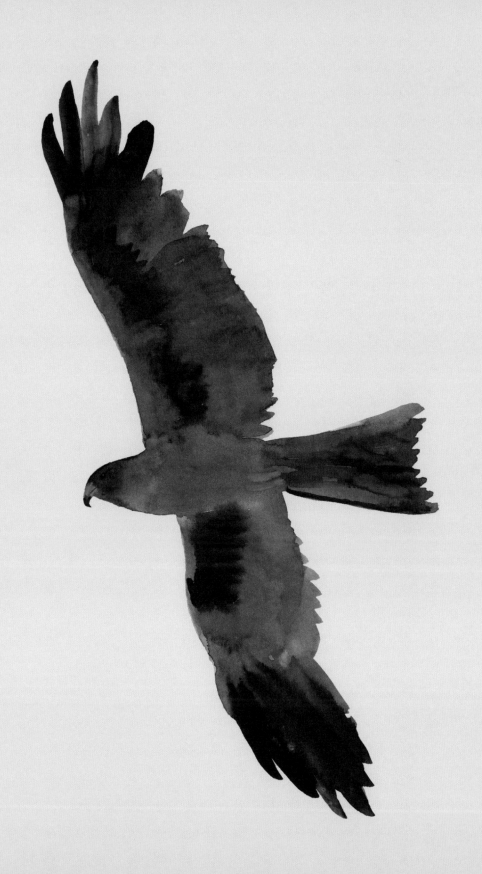

COPPERSMITH BARBET

Mumbai, India

Barbets are striking and unusual birds. Found in the tropical regions of South America, Africa and Asia, they are a plump, colourful species with large, powerful bills that are fringed with bristles that enable them to feed on insects and fruit.

16cm (6¼in)

17cm (6¾in)

42g (1½oz)

Most species of barbet are found in forests and savannahs, far from human habitation. But a handful of species have adapted to live alongside us in towns and cities, of which the best known is the coppersmith barbet.

Named after their metallic, metronomic call, which sounds rather like someone striking metal with a hammer, coppersmith barbets are found across much of the Indian subcontinent, as well as other parts of Southeast Asia. They have even moved into the vast city of Mumbai, home to over eighteen million people, where, against expectations, the birds have thrived.

However, they are not always easy to see in the city, earning them the local name of 'mysterious ghosts'. Although out in the open their bright-green plumage and crimson crown makes them very visible, they blend in surprisingly well with the foliage of their surroundings, and because they are so small – just 16cm (6¼in) long on average – they can be hard to spot. Their sound, though, is very distinctive, and has also been likened to the time signal from All India Radio.

Despite being more elusive than most urban birds, recently the coppersmith barbet was voted 'Bird of Mumbai' in a citywide poll, beating more familiar species such as the lesser flamingo, oriental magpie-robin and house crow. One Indian naturalist remarked at the time that he was astonished that this species has managed to survive in such a busy city, comparing its fighting spirit to that of the local people.

Like other members of its family, the coppersmith barbet makes a hole in a dead tree to nest, enabling it to live in the city's parks and gardens, where it often feeds on figs. The birds also use their nest holes to roost at night, sunning themselves the next morning on the tops of the trees. Occasionally, they are evicted from their nest holes by their larger relatives, the blue-throated barbets.

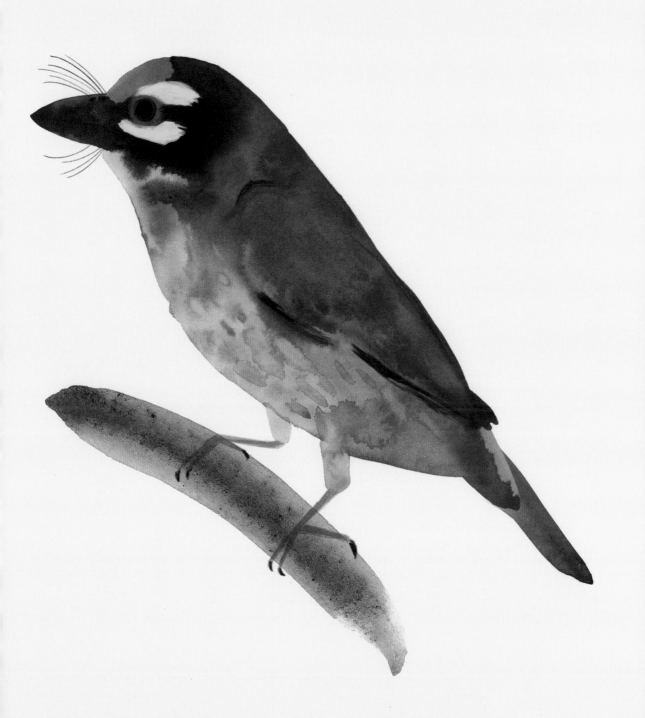

RED-WHISKERED BULBUL

Bangalore, India

19.5cm (7¾in)

28cm (11in)

30g (1oz)

Bulbuls are one of the most ubiquitous bird families in Asia, and have adapted well to living in cities. Of the 130-plus members of the family, few have embraced urban life quite so readily as the red-whiskered bulbul. The birds are so common in the southern Indian metropolis of Bangalore – the country's fifth-largest city – that the local press has dubbed them 'the new sparrows'. Bulbuls have even appeared in Bollywood movies, in a song whose title translates as 'Dance my Bulbul'.

A shade smaller than a starling, with a perky crest, brown upperparts and a white throat and cheeks, an adult bulbul also sports the distinctive red spot behind the eye that gives the species its common name.

The people of Bangalore have certainly taken to this handsome bird, which seems blissfully unafraid of the millions of human beings with whom it shares its space. The bird often nests really close to people, on the balconies of homes and in ornamental plants and trees in the city's gardens. Many residents avidly watch the progress of 'their' breeding pair of bulbuls, whose chicks look rather like miniature dinosaurs and appear to be permanently hungry, opening their mouths wide to demand food from their busy parents.

Bulbuls pair for life and are highly sociable. After breeding, the birds travel around the city in close-knit family groups, looking for the fruit and small insects on which they feed. They often perch out in the open on a tree or roof, uttering their loud, three-or-four-note call, said to sound like 'pleased-to-meet-you!'

Another of Bangalore's bulbuls, the darker-coloured red-vented bulbul, is known to be very aggressive in defending its territory. In the past, young bulbuls were taken from their nests and trained to fight one another, but this practice was made illegal in 2016. Both the red-vented and red-whiskered varieties have been introduced elsewhere in the world: the red-whiskered can be found in Los Angeles, Hawaii and Florida, as well as several Australian cities, including Sydney, Melbourne and Adelaide.

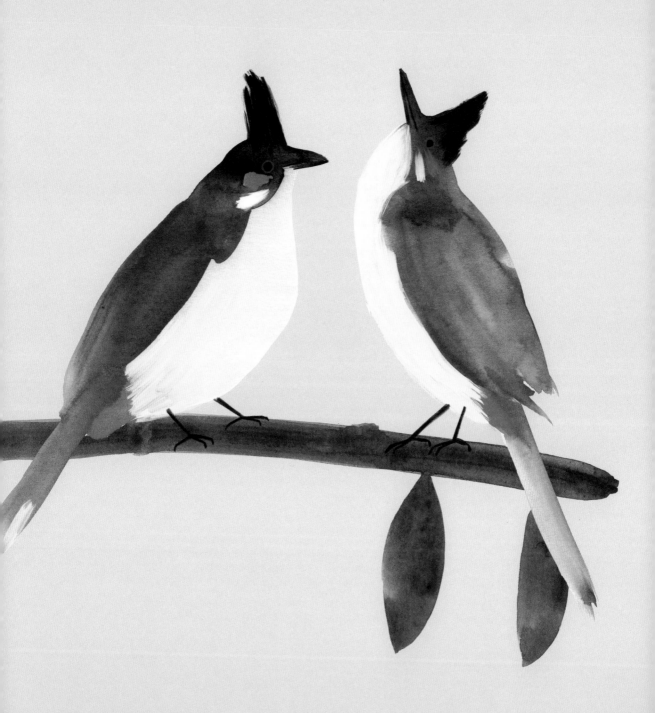

ORIENTAL MAGPIE-ROBIN
Dhaka, Bangladesh

Black-and-white birds may at first appear less striking and glamorous than their more colourful relatives, yet they often make up for their monochrome plumage with endearing character traits and habits. An example of this is the oriental magpie-robin.

About the size of a small thrush, with a black head, back, tail and breast contrasting with white underparts and white flashes on the wings, this charismatic member of the flycatcher family has a long tail, which it often holds upright as it forages for food on the ground. Females are greyer in appearance than males.

Found across much of Southeast Asia and the Indian subcontinent, the oriental magpie-robin has adapted well to city life. In the Bangladeshi capital of Dhaka, the seven million inhabitants have really taken this little bird to their hearts: it is not only Bangladesh's national bird, appearing on the country's banknotes, but it has even given its name to one of the capital's main squares – Doyel Chattar (*doyel*, or *w*, being the bird's local name). Inside the square, there is a statue of two birds with their wings outstretched – a tribute to the *doyel*.

Oriental magpie-robins are very common throughout Dhaka, especially in parks and gardens. Like many other Asian songbird species, they were once commonly kept as cage birds, because of their attractive appearance and song. In recent years, this has thankfully declined in popularity – the species was almost wiped out in Singapore during the twentieth century because of the illegal cage bird trade.

Magpie-robins start to breed from January onwards. The males hold territory, singing their loud and tuneful song from perches on the tops of trees and bushes. They also display to the females, puffing up their feathers and fanning their tails – a common sight in Dhaka's city parks. At this time, the males are so pumped up they often attack their reflections in the wing mirrors of cars, in the mistaken belief that they are seeing off rivals.

This pugnacious behaviour has not affected local people's liking for the bird: many provide traditional boxes in which the birds make their nests and raise their families.

20cm (8in)

25cm (9¾in)

40g (1½oz)

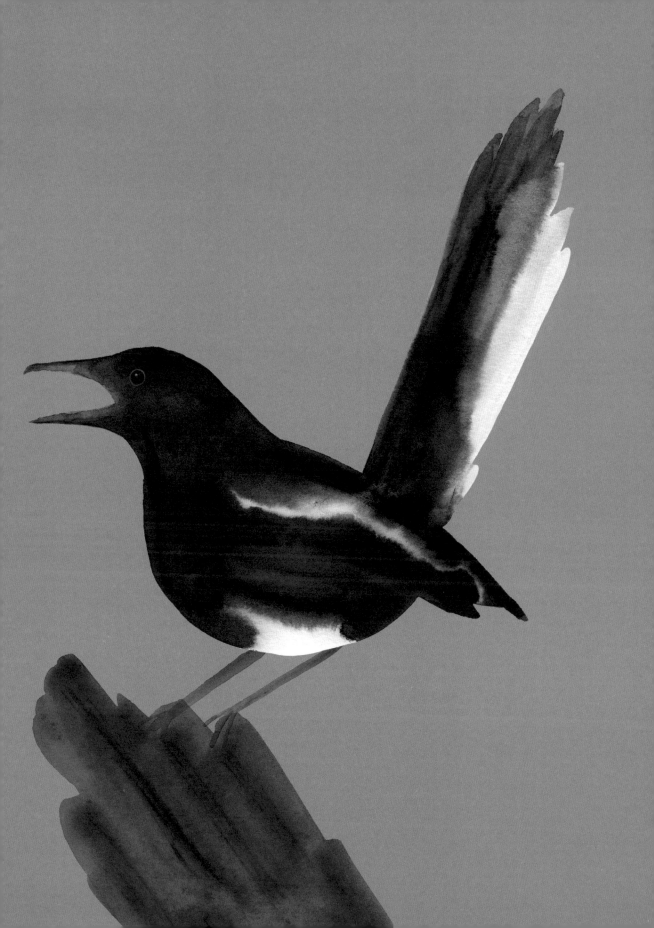

REED PARROTBILL

Shanghai, China

19cm (7½in)

18cm (7in)

21g (¾oz)

The powerhouse of China's economic transformation over the past few decades, Shanghai is home to almost twenty-five million people. You might not think that this city would make a great home for birds, yet a few remaining green spaces such as the city's botanical gardens, and its position on the Yangtze River Delta, mean that Shanghai is still home to a wide range of East Asian species – including the enigmatic and striking reed parrotbill.

Parrotbills are a group of twenty or so songbird species found in East and Southeast Asia, whose long tails and upright stance make them look very like the bearded tit (also known as the bearded reedling – though this has since been given its own family).

Reed parrotbills are long, slender birds – about 19cm (7½in) long on average, including their tails, with orange-brown bodies, grey cheeks, a prominent black stripe above their eyes and short but hefty, bright-yellow bills. As their name suggests, reed parrotbills are birds of wetland regions, living and breeding in reedbeds. Here, they feed mainly on tiny insects.

Once, much of the area in and around the Yangtze Delta would have consisted of reedbeds, but the rapid expansion of Shanghai has destroyed vast areas of habitat, with only a few small patches now remaining. Indeed, almost two-thirds of the whole metropolitan area of Shanghai was built on reclaimed wetlands. Because the parrotbill is mainly sedentary, it is unable to move to a new home when an old one is destroyed or fragmented by urban development.

In recent years, a new-found sense of environmental concern has led to the reed parrotbill becoming a symbol for the regeneration of natural and seminatural habitats around the city. It has also featured in a two-way race with a more familiar species, the light-vented bulbul, as Shanghai's municipality bird. Local birders and conservationists are hopeful that the remaining areas of precious wetland habitat – home to a wide range of other rare and threatened species that include the black-faced spoonbill, Nordmann's greenshank and spoon-billed sandpiper – can now be saved.

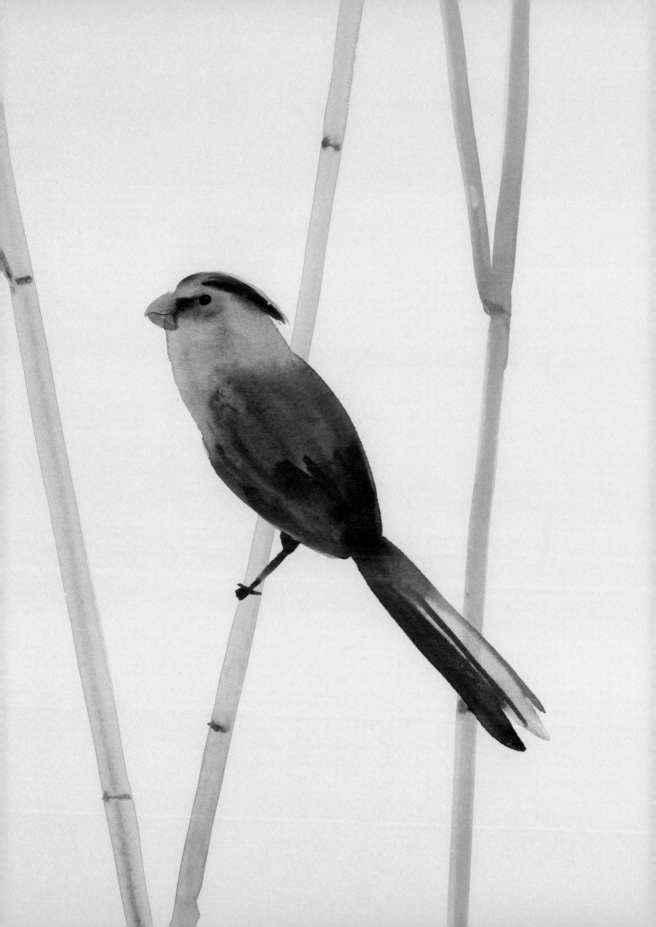

SPOON-BILLED SANDPIPER
Hong Kong, China

15cm (6in)

35cm (13¾in)

35g (1¼oz)

Of all the world's cities, few are quite so relentlessly urban as Hong Kong. Now part of China, but under British rule for more than 150 years, the city is one of the most densely populated places on the planet, with more than seven million people squeezed into an area of just over 1,100 square km (420 square miles).

Yet in the north of Hong Kong, close to the mainland Chinese city of Shenzhen, lies Mai Po marshes, one of the most internationally renowned wetlands in the world. Despite the pressure to develop the site, the marshes still provide a refuge for some of the world's rarest birds, including Saunders's gull, the black-faced spoonbill and the most endangered of all, the spoon-billed sandpiper.

At just 15cm (6in) long on average, this curious little wader is barely larger than a sparrow. As its name suggests, it has one unique feature: its spatulate bill. It feeds by sweeping its bill from side to side, giving it a very distinctive action, visible from some distance away.

Until the mid-1980s, the spoon-billed sandpiper was not considered especially rare, but as more of its wetland habitats were lost, its plight became clear. Today, the world population is estimated at between 250 and 500 individuals.

Since that time a global conservation programme, including captive breeding at the Wildfowl and Wetland Trust's headquarters at Slimbridge in the United Kingdom, has helped slow the decline, yet with so few birds now remaining, the species – classified as Critically Endangered – may well go extinct within the next decade or so.

The biggest problem facing the sandpiper is that it needs a series of wetlands to use as stopovers on its long journey south from its breeding grounds in eastern Siberia to its winter quarters in Southeast Asia. Many of these – including wetlands on the outskirts of Bangkok and Shanghai, as well as Mai Po – are now under threat from development.

Ultimately, the spoon-billed sandpiper may be the first casualty of the Asian economic miracle that has brought riches and prosperity to many, but has left wetland birds facing oblivion. But as long as they still appear in Hong Kong and other Asian cities, there is hope for their future.

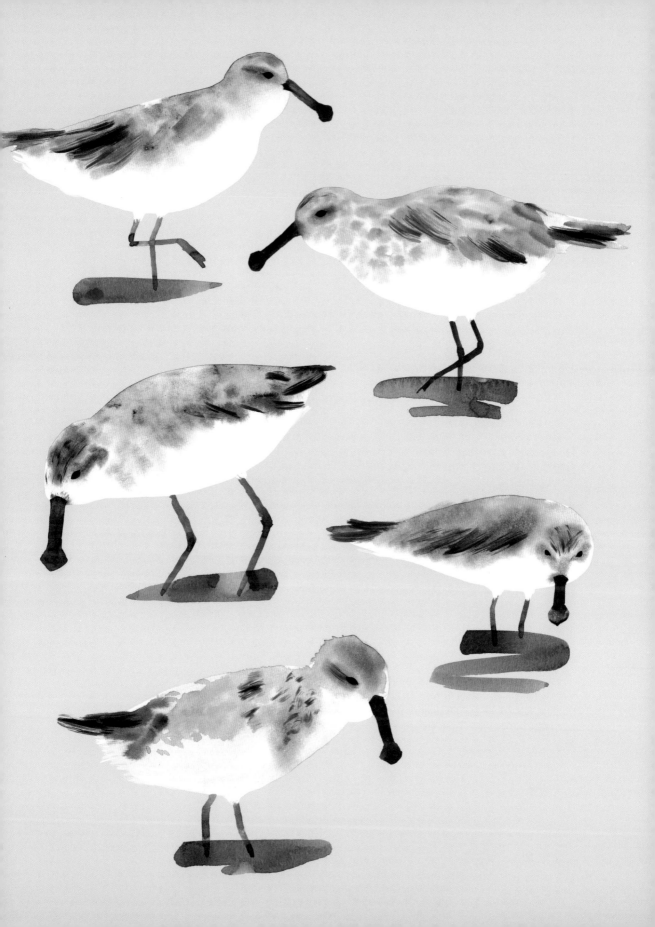

ZEBRA DOVE

Kuala Lumpur, Malaysia

Pigeons and doves (the latter term is usually used for smaller members of this family) have a very long association with human beings, and many of the world's 300 or so species are kept as cage birds because of their attractive appearance and docile nature.

21cm (8¼in)

25cm (9¾in)

60g (2⅛oz)

Keeping doves as pets has a long tradition in Malaysia and one species – the zebra dove – is particularly prized for its ability to sing. The zebra dove, also known as the barred ground-dove, gets its name from the narrow black-and-white stripes on its neck and sides. About the size of a starling, with a slender body and long tail, it can be found across much of Southeast Asia.

This species has adapted well to living in the region's cities, being especially abundant in the Malaysian capital of Kuala Lumpur, where it nests in parks and gardens. The birds can thrive because they have a long breeding season, which runs from September through to the following June.

The male takes the lead in courtship, cooing and bowing to his potential mate. Having paired up, both male and female build a nest, in which the female lays one or two white eggs. These hatch a couple of weeks later, and the young stay with their parents for one week longer.

The birds are a common sight in Kuala Lumpur as they forage for food, usually alone or in pairs, on the city's lawns and other open spaces. They can be seen pecking at the ground with their short bills to find small insects and seeds. They will even feed on the city's streets, though this can be dangerous given the speed and density of traffic. The zebra dove's striped plumage provides surprisingly good camouflage.

Each year, competitions featuring singing zebra doves are held throughout Malaysia, often held on public holidays such as the king's birthday or Malaysia's National Day. Some competitions see as many as 1,000 birds; the champion birds – and their descendants – can command very high prices.

As with many other species of pigeon and dove, the zebra dove has been introduced around the world, and today can be found on oceanic islands such as Hawaii, Tahiti and Mauritius.

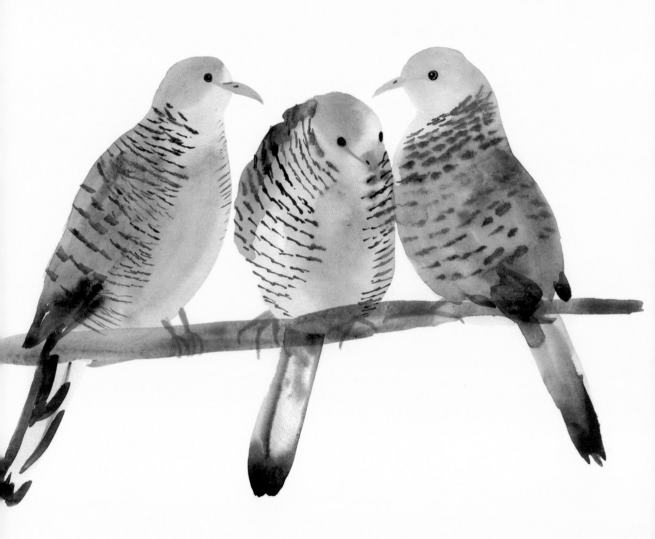

JAVAN MYNA
Singapore

As its name suggests, the Javan myna is native to the Indonesian islands of Java and Bali, but along with so many other members of the starling family, it has been deliberately or accidentally introduced to other countries in Asia, including Malaysia, Taiwan, Japan and the city-state and island of Singapore. Like its relatives, the bird has adapted surprisingly well to urban life, thanks to its varied diet and ability to live happily alongside human beings.

At 24cm (9½in) long on average, and weighing about 100g (3½oz), the Javan myna is a little larger and heavier than a European starling. It has a mainly black plumage, with brownish-black wings. Touches of white on the primary feathers and beneath the tail have given the species the alternative name of white-vented myna. The bird has yellow legs and feet, and a yellow bill with a small tuft of feathers just above.

The Javan myna was first brought to Singapore as a popular cage bird in the 1920s, thanks to its ability to mimic human voices and other sounds. Inevitably some either escaped or were deliberately released, and today there are as many as 100,000 at large in Singapore alone. They are so successful that they have now become a major pest species, as they feed on fruit from trees.

Attempts to discourage or get rid of the birds have included intimidating them using captive hawks, but this ended badly when the huge flocks of mynas chased away their would-be attackers. To try to deter the birds from breeding, a sticky gel was applied to the branches of the city's trees, but they simply used the gel as a glue to stick down leaves and build nests.

The Javan myna may be a pest in Singapore, but in its native home it is down to fewer than 2,000 individuals following the destruction of its forest habitat, and is now classified as Vulnerable to Extinction. One solution to its decline may be to collect mynas living in cities such as Singapore and release them in Java and Bali. However, critics claim that this will simply encourage more illegal trading of the birds.

24cm (9½in)

24cm (9½in)

100g (3½oz)

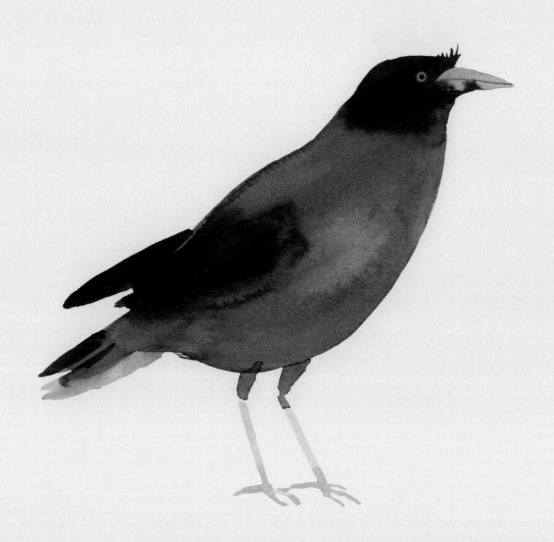

JAPANESE CORMORANT
Kyoto, Japan

Cormorants are excellent anglers, able to dive deep beneath the surface of seas, rivers and lakes to find their fishy food, which they catch in their powerful bills. In many parts of Asia, including Japan, various cormorant species have long been employed by human fishermen to catch their quarry.

86.5cm (34in)

1.5m (5ft)

2.9kg (6½lb)

Today, in the city of Kyoto – formerly the country's Imperial capital – Japanese (also known as Temminck's) cormorants are still used for this purpose, mostly along the Hozu River on the city's western fringes.

First, the migratory birds are caught when at roost, and then trained over six months or more. This involves fastening a ring around the cormorant's neck, loose enough to allow the bird to catch a fish, but tight enough to prevent it from swallowing.

Once the catch has been made, the fisherman reels the bird in, takes the fish and then releases the cormorant back into the water. Traditionally in Japan, cormorants would specialise in a local delicacy known as 'sweetfish'. A catch commanded a higher price if showing the distinctive marks on the side of its flesh that revealed that it had been caught by a cormorant.

In China, cormorants are traditionally allowed to eat every eighth fish they catch as a reward. Without this, a bird might refuse to dive again. In Japan, a bird is still able to feed on smaller fish, even with a ring around its neck.

Though often considered cruel and exploitative, cormorant fishing has a long global tradition, having been practised widely by civilisations ranging from ancient Egypt and Peru to Greece and much of Southeast Asia. Normally, cormorants have a lifespan of up to seven years, but in captivity can survive as long as two decades. Fishermen often become very close to their birds, massaging their bellies and necks after their work is over.

Today, most cormorant fishing in Kyoto is performed to attract tourists, rather than for the value of the fish themselves. It usually takes place on the Hozu River at night, when a boatman makes a fire on one end of his craft to help flush the fish out from their underwater hiding places.

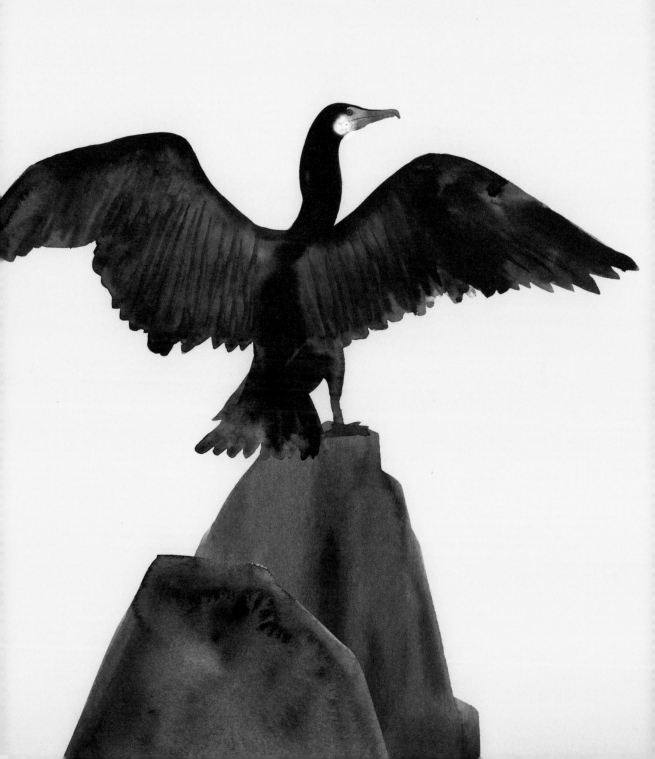

CARRION CROW

Tokyo, Japan

50.5cm (20in)

98cm (38½in)

500g (1lb)

Crows are famously intelligent birds that have been compared to primates and dolphins in terms of their ability to solve problems. Rooks in England know when litter bins are full or empty by watching the people who use them, while the New Caledonian crow is not only able to use tools, but can make them as well. In Japan's bustling capital city of Tokyo, crows have taken their skills to new levels in order to get access to their favourite food of nuts.

Nuts are nutritious and filling, but they present a problem to crows: they have hard shells, which means that even a bird with a powerful bill finds it hard to crack them open. So, having found a nut, a hungry crow will fly up above a lane of traffic and drop the nut in the path of a passing vehicle. More often than not, the tyres smash open the hard shell, enabling the crow to get at its contents.

Clever enough, you might think, but as David Attenborough revealed on the 1998 series *The Life of Birds*, Tokyo's crows then go one step further: they wait patiently until the traffic lights turn red and the traffic stops, before flying down to grab their booty. It has even been known for considerate drivers to run over the nuts deliberately in order to help the crows.

Even before the advent of motor traffic, crows have long been observed dropping food from a height to crack it open – gulls are known for doing the same with shellfish – but this was the first time that the two-stage process of dropping, then waiting, had been recorded, confirming crows' status as one of the world's most intelligent birds.

The Japanese name for the species, *hashi-boso-garasu*, translates as 'mean, thin-billed crow' (to distinguish them from the larger-billed jungle or Japanese crow). In Japanese culture, the sound of carrion crows flying to roost each evening is a signal for children to return home for their supper.

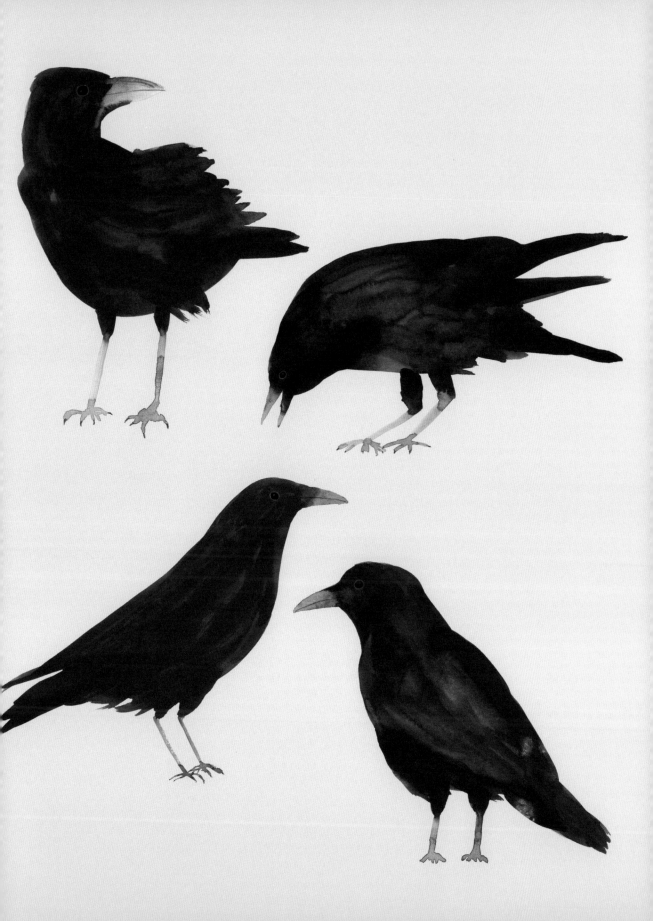

BLACK SWAN

Perth, Australia

1.3m (4¼ft)

1.8m (6ft)

7.7kg (17lb)

When the early settlers first came across black swans in Australia, towards the end of the seventeenth century, they could not believe their eyes. To them, all swans were white, and the notion of a 'black swan' – meaning something that could not possibly exist – was a long-held idea in Western civilisation.

This myth was finally busted in 1726, when two black swans were captured and shown to doubting sceptics. Even then, they were regarded with suspicion, being dubbed 'witches' birds', and portrayed as the evil alter ego of the white swan in Tchaikovsky's ballet *Swan Lake*.

In its native Australia the black swan is far more popular, being central to many aboriginal legends. It is also a familiar sight in most cities, especially in the southeast and southwest of the country, including the Western Australia capital of Perth. Indeed, the city's main waterway, Swan River, was named for the black swans that still occur there in large numbers – the species is even commemorated there with a large bronze statue. Black swans are also very common on Lake Monger, in the city's suburbs. As a result of their ubiquity, a black swan against a gold disc graces the state flag (and is also found on the coat-of-arms of the country's official capital, Canberra).

Most black swans living in Perth are sedentary, remaining there all year round. But elsewhere the population is, like that of many other Australian birds, largely nomadic, flying many miles by night in search of new wetlands so that they always have a ready supply of food.

Although from a distance, the black swan does indeed appear completely black, a closer look reveals that its plumage is mottled with lighter feathers, and in flight it reveals large white patches on its wings. It also sports a blood-red bill and, although it is smaller than the mute and whooper swan, at 1.3m (4¼ft) long on average, and weighing 7.7kg (17lb), it is still large compared with most waterbirds. It is also one of the most graceful, with the longest neck relative to its body size of all the world's swans, often held in an elegant, S-shaped curve.

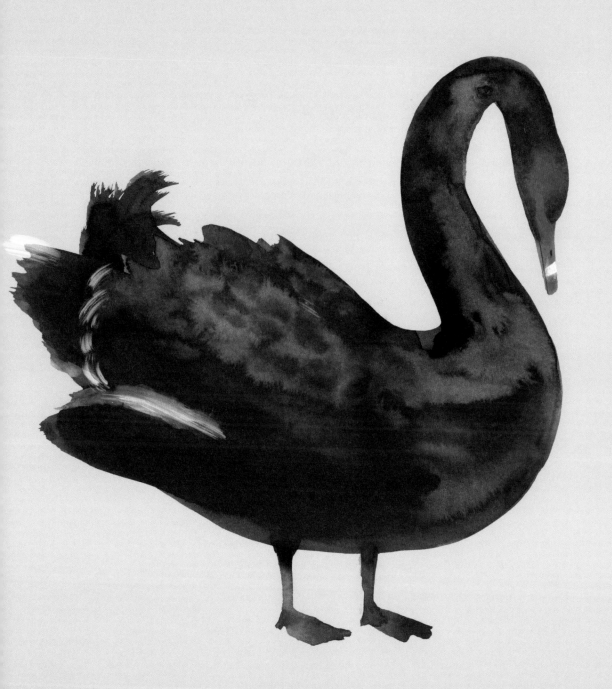

BUSH THICK-KNEE
Cairns, Australia

Thick-knees – also known as *dikkops* in South Africa (Afrikaans for 'thick-heads') and, in Britain, stone curlews – are curious birds. Most of the world's nine species are nocturnal in their habits, rarely seen during daylight hours. But in Australia two species – the beach and bush thick-knees – are far more obliging. Although they are still most active at night, they can often be seen during the day.

As their names indicate, the beach thick-knee is found mainly on sandy beaches along the coast, while the bush thick-knee prefers drier areas, inland. Both can be seen in the Australian city of Cairns.

Cairns is the gateway to both the Great Barrier Reef and the birder's paradise known as Tropical North Queensland (TNQ). You don't need to leave the city boundaries to see great birds, however. Bush thick-knees are a frequent sight in the city parks and open spaces, though they do tend to stay still during the day, using their streaky plumage as camouflage.

The bush thick-knee is a slender, long-legged wader, with a distinctively rounded head and short, thick, stubby bill. In flight it shows white flashes on the wings.

Once dusk falls, and the city becomes less busy, flocks of up to twenty bush thick-knees can be seen searching for food using their large, round eyes. As a species of open grassland habitats, they have adapted very well to life alongside people. They particularly like golf courses, of which there are plenty in this sunny region. In the state capital Brisbane they breed in the city parks, feeding in the shopping district after dark.

Bush thick-knees are especially attracted to street lights, under which gather large concentrations of beetles and geckos, the birds' favourite food. They also eat frogs, snakes, lizards and small mammals. Bush thick-knees even pick up cigarette butts and use them to line their nest – possibly, some scientists have suggested, because the nicotine acts as a deterrent to parasites.

In some cultures, thick-knees are regarded as harbingers of death – probably because of their nocturnal activities. In other traditional stories, the bird represents a mother who is searching for her lost child – presumably based on the bird's haunting, wailing calls.

56cm (22in)

56cm (22in)

670g (1½lb)

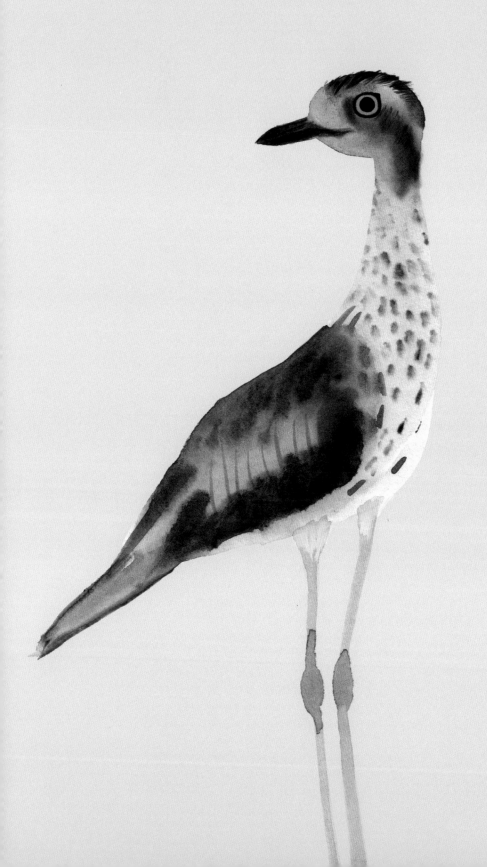

AUSTRALIAN BRUSH-TURKEY

Brisbane, Australia

With its fanned tail, jaunty walk and long yellow wattle hanging from its throat, this bird may look like a turkey, but it actually comes from the megapode family. These unusual birds live in the dense jungles and rainforests of Southeast Asia and Australia. Just one species – the Australian brush-turkey – has adapted to living alongside humans in urban and suburban areas.

Megapodes do not build conventional nests. Instead, the male creates a huge mound from vegetable matter, inside which his mate lays her eggs. The very warm temperature inside the mound – 33°C (91°F) – means that the female never has to incubate her precious clutch. Instead, the male stands guard outside, warding off any curious passers-by, until the chicks hatch. The chicks are then left to fend for themselves – a strategy with a very heavy mortality rate; just one in two hundred brush-turkeys reaches adulthood.

In the suburbs of Brisbane, as in other Australian towns and cities, male brush-turkeys can cause huge damage, stripping gardens within a radius of up to 100m (109yd) of their vegetation, to construct that huge mound.

Brisbane's city council offers advice on how to discourage the birds, including putting up a large mirror (which is supposed to confuse any male into thinking the territory is already occupied), covering your compost heap, or starting a 'neighbourhood watch' scheme to see the birds off. Other gardeners encourage the birds, as at the end of the season they have lots of free compost!

During the past two decades, the Brisbane population of brush-turkeys has grown more than sevenfold, and the birds have started to spread down the coast towards Sydney. This is a major turnaround from the 1970s, when the species was classified as endangered. A subsequent ban on hunting the birds has allowed them to bounce back with a vengeance.

In 2017, the brush-turkey was a contender for 'Australian Bird of the Year', and was described as 'the avian archetype of the Aussie battler – persisting and thriving, even though the odds are stacked against it'.

65cm (25½in)

85cm (33½in)

2.4kg (5¼lb)

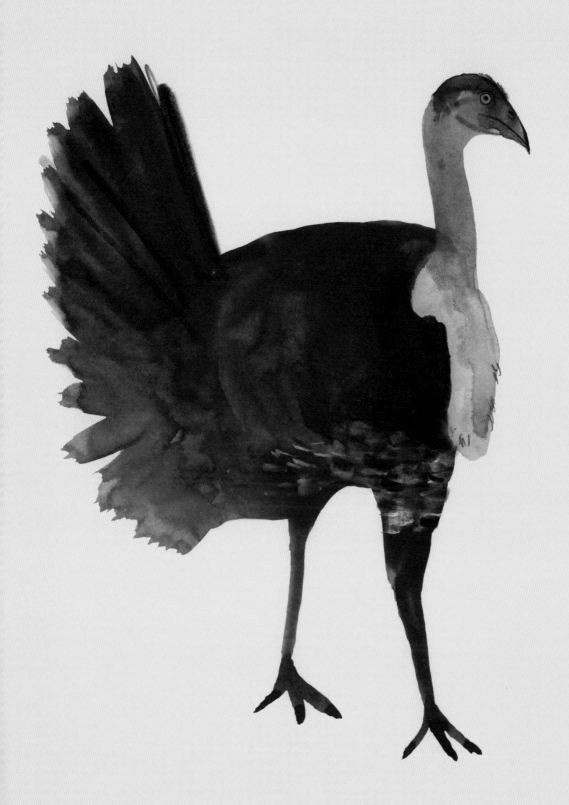

SATIN BOWERBIRD

Canberra, Australia

32.5cm (12¾in)

48cm (19in)

230g (8oz)

The breeding areas and nests of most birds are deliberately camouflaged to avoid the attention of unwelcome predators. However, one family – the bowerbirds of New Guinea and Australia – goes out of its way to draw attention to its courtship place, or bower, by decorating the area around it with an extraordinary range of items – both natural and man-made.

The male does all the hard work, while the female makes a tour of the neighbourhood, judging each male on his handiwork and the quality and number of items on display, before mating with the most dominant bird.

In 1940, one satin bowerbird bower was found to contain the following items: eight bags, ten pieces of matchbox, one cigarette packet, one piece of string, thirty-four pieces of glass, seventeen feathers, some marbles, a car-park ticket, four chocolate wrappers and an invitation card. These disparate items had one thing in common: they were all coloured blue. Today, an equally bizarre assortment of decorations can be found in the bowers of satin bowerbirds in Australia's capital city Canberra; however, they are likely to include far more items made of plastic.

This handsome, glossy-blue bird has adapted very well to urban life, and is often found in the city's gardens. Numbers rise dramatically in the winter months, when birds from the tropical north migrate south from their forest homes to find food in the city.

Such a conspicuous bird, with its unusual breeding behaviour, attracts much attention in Canberra, both in the local media and from residents. The birds have been known to decorate their bowers with bottle tops, pen lids and clothes pegs, as well as natural items including flowers and berries. Male satin bowerbirds will sometimes even vandalise the bower of a rival, to reduce the competition.

Showy though the bower may be, in fact the satin bowerbird does not have such an elaborate courtship arena as some of his relatives. This is thought to be because, unlike many other bowerbirds, which are mainly rather dull, the satin bowerbird is a handsome, colourful creature.

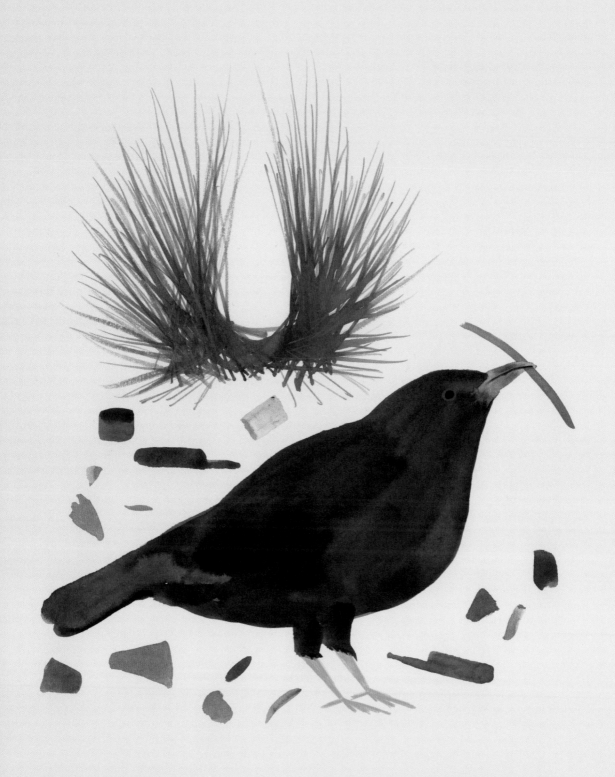

RAINBOW LORIKEET
Sydney, Australia

The British and the Americans are well known for their habit of feeding garden birds. Although both nations can boast attractive species, from the goldfinch and blue tit to the cardinal and blue jay, none can compete with one of Sydney's regular garden visitors, the rainbow lorikeet.

This bird really does come in almost every colour of the rainbow. The head and face are bluish-violet, the neck lime green, the back and tail dark green, the breast and flanks orange-red, the sides yellow and the belly dark blue. Male and female are alike, though youngsters have duller plumage. They are mostly monogamous, and generally pair for life.

Rainbow lorikeets are members of the parrot family: about the length of a pigeon, though much slenderer, with a large head and long tail. Like most parrots, they are intelligent, sociable and easily trained, so are often kept as cage birds. Yet their native range is quite small: they only live in the coastal regions and hinterland, from northern Queensland to South Australia. There is a small but stable feral population in Western Australia, descendants of birds accidentally released there during the 1960s.

These birds bring a welcome splash of colour to Australia's biggest city. Regular visitors to garden bird feeders, they gather in large, noisy flocks, sometimes being quite aggressive to other birds. After feeding, when they disperse, they often split up into pairs.

In its natural habitat, the rainbow lorikeet feeds mainly on fruit, nectar and pollen, using a special appendage on the end of the tongue to extract the latter from flowers. Sydney is especially good for lorikeets as it offers an incredible diversity of flora in a relatively small urban area.

Like all parrots, rainbow lorikeets nest in holes, usually in trees such as eucalyptus, but sometimes in cracks and crevices in rocks. As befits such a common cage bird, even wild lorikeets are often very tame, and can easily be fed from the hand. However, they are far less popular with fruit growers, as they can rapidly strip an orchard of its contents.

27.5cm (10¾in)

46cm (18in)

120g (4¼oz)

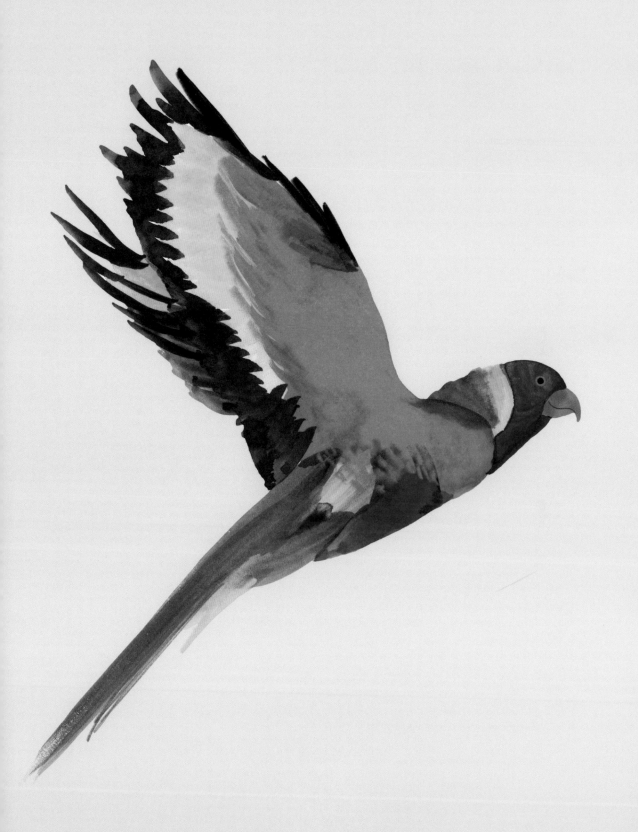

AUSTRALIAN WHITE IBIS
Melbourne, Australia

Birds evolve to live in specific habitats and some seem to adapt far better than others when it comes to living in cities. One such bird is the 'bin chicken' or, to use its official name, the Australian white ibis, a wetland species that has taken to urban life with ease.

69.5cm (27½in)

1.2m (4ft)

2kg (4½lb)

This tall, dirty-white bird with a black head and tail and long, downcurved bill, has become something of a pantomime villain in many urban areas, including the capital of the Australian state of Victoria, Melbourne. The bird earned its unattractive folk name from its habit of finding food by scavenging amongst refuse. Other affectionate names for the bird include 'dump chook', 'trash vulture', 'garbage flier', 'winged waste lizard', 'refuse raptor', 'picnic pirate' and 'tip turkey'.

One scientist initially found the bird's bin-raiding habits gross, but having studied the species for a while, he began to appreciate its adaptability, noticing that some birds even had distinctive personalities.

Melbourne's ibises feature prominently in popular culture, with humorous YouTube videos about the city's birds going viral on occasion. In 2017, the bird almost won a *Guardian* newspaper poll to find the Australian Bird of the Year, being beaten only narrowly by the Australian magpie. Not surprisingly, the Australian white ibis is one of the most frequent birds to feature on social media. It has inspired events, too: in December 2016, no fewer than 8,000 people turned out for 'International Glare at an Ibis Day'.

Ironically, though, the Australian white ibis is living in Australia's cities because much of its wetland habitat in rural areas has been drained. So, while many citydwellers find its habits distasteful, the ibis is there because of our own wasteful and destructive habits. How different this is to ancient Egypt, where the sacred ibis was a symbol of Thoth, the god of writing and wisdom.

Elsewhere in Australia, the white ibis is found in Sydney (where it is known as the 'Bankstown bin diver' after a suburb of that name), and also in Brisbane, Gold Coast and Perth.

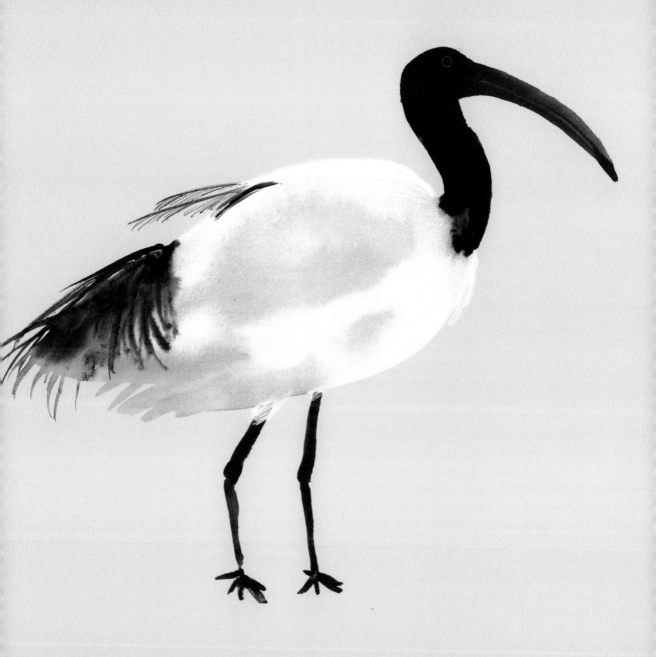

WRYBILL

Auckland, New Zealand

20cm (8in)

50cm (19¾in)

55g (2oz)

Many birds, such as curlews, have downcurved bills. A few, such as the avocet and Terek sandpiper, have a bill that curves upwards. But only one of all the world's 10,000 and more species of bird has a bill that curves from one side to the other: the aptly named wrybill.

The wrybill is a small member of the plover family, found only in New Zealand, and nowhere else on the planet. In summer, it breeds along the pebble-fringed banks of rivers and streams of South Island, in upland areas close to the main city of Christchurch. But each December and January, virtually all the world's wrybills head north, to spend the southern hemisphere autumn and winter in the milder climes of North Island.

From this time of year onwards, large gatherings of the birds occur around the country's largest city, Auckland. One well-known wader roost, at Mangere Harbour towards the south of the city, supports a winter roost of up to 20,000 waders, including a peak count of 1,670 wrybills. Given that the world population of the species is estimated to be just 3,000 to 3,500 individuals, this is an incredible total.

Wrybills can be picked out amongst the larger waders by their small size – just 20cm (8in) long, on average. They are generally greyish-brown above and white below, and the male has a prominent black band across the upper breast. Of course, the most distinctive feature is that extraordinary bill, which always curves from left to right. The bird uses this to lift up small stones to find aquatic insects and their larvae hiding beneath, on which it feeds. At high tide they roost away from the harbour, including on the grassy areas of Auckland Airport, where some have unfortunately been killed in collisions with aircraft.

Wrybills are well known in New Zealand. In 2010, they appeared in a children's book written by Jane Buxton, *Ria the Reckless Wrybill*. This tells the story of a young wrybill whose beak curves to the left instead of the right, and who ignores her parents' advice to hide from predators, with potentially fatal consequences.

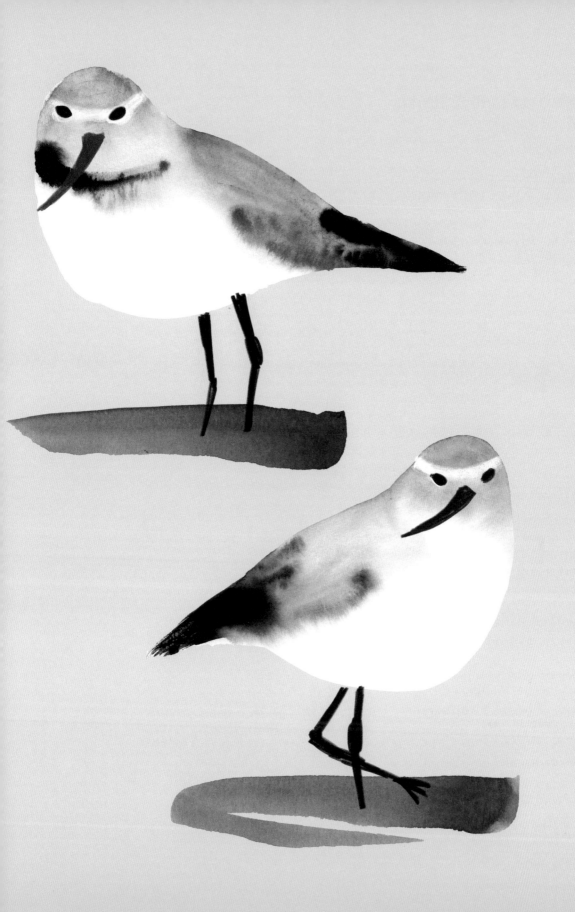

NEW ZEALAND BELLBIRD

Christchurch, New Zealand

18.5cm (7¼in)

28cm (11in)

28g (1oz)

Throughout the world, there are birds named for the sounds they make, and these include several different and wholly unrelated groups known as 'bellbirds'. Named for their very loud, ringing calls, one such group is found in South America and several species in Australia. In New Zealand, there is just one species: the New Zealand bellbird.

Also known by several Maori names, including *korimako* and *makomako*, this small, greenish songbird of the honeyeater family is found nowhere else in the world. A little larger than a sparrow, it has a blackish head, wingtips and tail. Its main feature, however, is its long, downcurved bill, which enables it to feed on nectar from flowers. It has a specially adapted brush-like tongue, which it uses to collect pollen.

The New Zealand bellbird is most famous for its unmistakable song, which can be heard in urban and rural areas throughout the country, including the city of Christchurch on South Island. The species was first reported by the earliest European settlers, including Captain James Cook, who praised it for its song, which he said sounded like 'small bells most exquisitely tuned'.

In recent years, the New Zealand bellbird has been in decline, partly due to the destruction of its forest habitat for farming, and also because of introduced predators such as cats and rats, which wreak havoc on native bird species. In Christchurch, however, the bird is on the increase, thanks to the systematic control of pests and the provision of substitute habitat in gardens. One of the city's main landmarks is called 'The Sign of the Bellbird', and was named in the early-twentieth century as a way of celebrating the city's native fauna. Recent studies carried out in Christchurch have also shown that the bird's song varies dramatically from one location to another, even when these are quite close within the city boundaries.

Today, bellbirds are very popular members of Christchurch's avifauna, and are encouraged by homeowners, who put up nectar feeders and plant native plants. A new urban forest has also been planted as a home for the species, and brings the added benefit of helping protect the city from flooding.

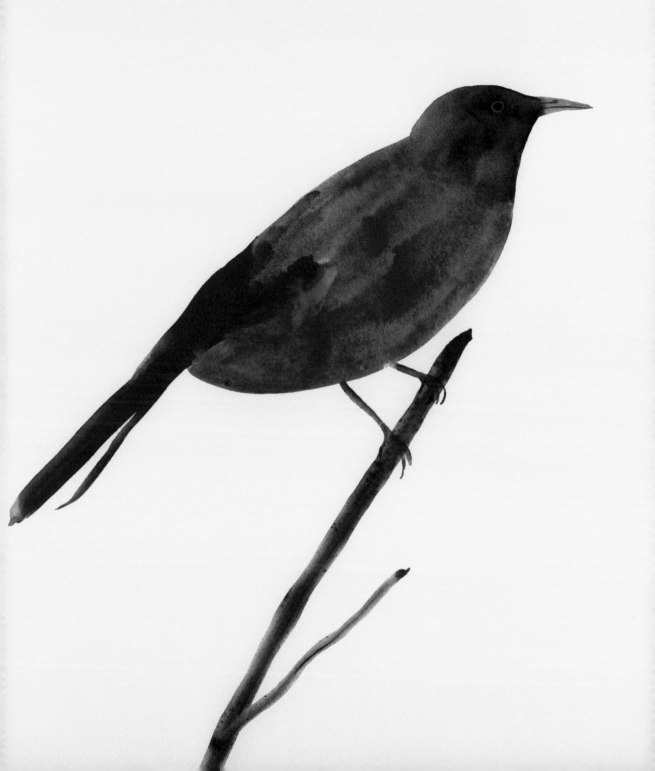

ACKNOWLEDGEMENTS

At White Lion Publishing, I would like to thank Melissa Hookway for initially commissioning the book, Lucy Warburton for overseeing the project and for her perceptive comments on the text, and editor Joe Hallsworth for seeing the book through to completion.

My sincere and grateful thanks also go to Liam Curson, who provided really useful and detailed research on the vast majority of the species included in the book, and compiled the statistics on size, wingspan and weight.

Finally, any book on urban birds must acknowledge the work and influence of my dear friend David Lindo – aka 'The Urban Birder' – who has done so much to promote birding in cities around the world, through his books, articles and visits. As he says, if you want to see birds in the concrete jungle, 'just look up'!

FURTHER READING

Birds and People, by Mark Cocker and David Tipling (Jonathan Cape, 2013)

Birdwatching London, by David Darrell-Lambert (Safe Haven Books, 2018)

Nature in Towns and Cities, by David Goode (Collins New Naturalists, 2014)

The Urban Birder, by David Lindo (New Holland, 2011)

Tales from Concrete Jungles, by David Lindo (Bloomsbury, 2015)

How to Be an Urban Birder, by David Lindo (WILDGuides, 2018)

Where to Watch Birds in World Cities, by Paul Milne (Helm, 2006)

INDEX

Brimming with creative inspiration, how-to projects and useful information to enrich your everyday life, Quarto Knows is a favourite destination for those pursuing their interests and passions. Visit our site and dig deeper with our books into your area of interest: Quarto Creates, Quarto Cooks, Quarto Homes, Quarto Lives, Quarto Drives, Quarto Explores, Quarto Gifts, or Quarto Kids.

First published in 2019 by White Lion Publishing,
an imprint of The Quarto Group.
The Old Brewery, 6 Blundell Street
London, N7 9BH,
United Kingdom
T (0)20 7700 6700
www.QuartoKnows.com

A catalogue record for this book is available from the British Library.

ISBN 978 1 78131 840 9
Ebook ISBN 978 1 78131 841 6

10 9 8 7 6 5 4 3 2 1

Design by Paileen Currie
Printed in China